haha

margam revisited

haha
margam revisited

ffotogallery & seren

HaHa · Margam Revisited
Published by Ffotogallery & Seren

Edited by Christopher Coppock & Karen Ingham

FFOTOGALLERY
c/o Chapter
Market Road
Cardiff CF5 1QE
www.ffotogallery.org
ISBN: 1 872771 21 1

SEREN
38-40 Nolton Street
Bridgend
CF31 3BN
www.seren-books.com
ISBN: 1 85411 330 5

Ffotogallery is supported by the Arts Council of Wales & Cardiff County Council
Seren works with the financial assistance of the Arts Council of Wales

publication production: Christopher Coppock
cover printed on 240gsm Invercote G
text printed on 150gsm Essential Satin
printed by D.W.Jones (Printers) Limited, Empire Buildings, Beverley Street, Port Talbot, SA13 1DY

Published in an edition of 1,000
November 2002

Hugh Adams would like to thank his brother Philip Adams for his unfailing patience,
particularly in answering many enquiries connected with this essay.

The Ffotogallery exhibition, HaHa · Margam Revisited
which co-incided with this publication
took place at the Orangery, Margam Country Park, near Port Talbot
from 12th - 28th November 2002

The publishers wish to acknowledge the financial support of
Neath Port Talbot County Borough Council and its Education, Leisure and Life Long Learning Department,
the Centre for Lens-Based Arts at Swansea Institute of Higher Education
and the generous sponsorship from D.W.Jones (Printers) Limited of Port Talbot in the production of this book

chris dyer

peter finnemore

tatjana hallbaum

karen ingham

adam o'meara

richard page

matthew pontin

miranda walker

ha–ha[2] ('ha: ha:) *or* **haw–haw** *n.* a wall or other boundary marker that is set in a ditch so as not to interupt the landscape. [C18: from French *haha*, probably based on *ha!* ejaculation denoting surprise]

Perhaps more than any other genre, landscape photography still retains the visible residue of its evolution from eighteenth and nineteenth century landscape painting. Particularly in relation to the notion of the 'picturesque', British landscape photography developed within a highly encoded tradition, one which sought to produce images that reinforced and perpetuated the class hierarchies of the day. These hierarchies of significance were in many ways epitomised by the raised country estate, surveying all from its lofty position on the hill, well away from the labouring classes on whose backs the estate was built.

So as to appear to be part of the surrounding wilderness, that 'dangerous' space just beyond the land-owners purview where man and nature were not so tightly controlled, the Royal Gardener at Rousham, Charles Bridgeman, designed the *haha*, a cleverly constructed ditch that seamlessly separated the estate from the surrounding common lands. Taking their inspiration from the ornate Italianate landscapes of the 'grand tour', other noted eighteenth and nineteenth century gardeners and architects created increasingly elaborate follies such as Grecian temples and Palladian columns.

The painter Claude Lorraine was also influential in the perpetuation of the picturesque landscape. Commenting on the artifice of the Eden Project, writer Lisa Le Fèvre notes that Lorraine's influence extended to the creation of a special pair of glasses for viewing the landscape. *"The phenomenon of the 'Claude glasses' at the end of the seventeenth century is interesting to note. The glasses were looked through to create a restricted view where 'what was not defined as nature' could be edited out to create an ideal view of landscape — in particular one that could have been created by the painter Claude Lorraine."*

When Henry Fox Talbot succeeded in creating his 'pencil of nature' (the *calotype* in 1840), his invention became part of a wider socio-political discourse, that of the great Enlightenment quest for universal knowledge, and a more pervasive kind of 'Claude glasses' were invented. Photography was dependent upon a range of industrial processes (such as silver mining), and in its rapid evolution from complex and elitist scientific experiment to a cheap and easy method of mass reproduction, photography became in itself an industrial process.

The dialogue between picturesque landscape painting, the empirical lens, and the hierarchical visual lexicon of nineteenth century British landscape photography, is still in evidence at the Margam estate in South Wales. Part of the extended Talbot family estates, Margam was home to some of photography's earliest experiments, such as the Reverend Calvert Jones' 1841 view of Margam Castle presently held in the archive of the National Library in Aberystwyth.

Despite the fact that much of the South Wales landscape has been damaged by industrial processes, the Margam/Port Talbot landscape is extreme by any standards and is emblematic of a more widespread industrialisation evidenced in many other Western industrial societies. Here the quest for ever greater speed and accessibility has led to the rise of inter-liminal hinterlands that occupy a hybrid position (part wilderness, part urban sprawl) with the vestiges of community life pushed from the centre to the margins. In this instance 'nature' must be ever more constructed, managed and marketed, hence the rise of the country park such as Margam. At first glance it would seem that Margam is adrift from its past and, as yet, uncertain of its future, like a theme park without a theme.

By becoming increasingly interventionist in how we manage and market these sites, we exacerbate a sense of division and subconsciously reinforce cultural opposites: privileged, under privileged, surveyor, surveyed, urban, rural, industrial, pastoral. And yet in many ways our fixation with TV DIY and 'instant gardening' has blurred the boundaries between these binaries, leading to an elision between high and low culture. The emblems of power and privilege are now mass reproduced and readily available at garden and DIY chain stores throughout the land — mock Grecian statues, Palladian columns, cherubic fountains, pergolas, designer topiary, reconstituted stone lions, and personally initialled wrought iron gates — imitation replicas of a mythic Arcadia that we aspire to in miniature.

We continually renew and regenerate the notion of landscape, becoming increasingly synthetic and mercantile in our construction of 'nature'. This spirit of rejuvenation can be witnessed in the way the communities of Margam and Port Talbot have responded with surprising resilience to the dramatic changes in their environment. A strange synthesis has occurred between surveyor and surveyed. Beneath the motorway, residents have unconsciously appropriated the symbols of their former Arcadian masters, incorporating the formidable concrete pillars and forty foot high cement walls of the M4 into their own highly individual versions of Palladian columns and walled gardens. One house uses the pillars to support a climbing rose, while in another an espaliered fruit tree shows off its bounty of spring blossom against a vast expanse of oppressive grey concrete. Meanwhile, on the very edge of the steelworks, a child's water shooter echoes the cylindrical configurations of the furnaces and cooling towers. A twenty-first century fantasy played out against a nineteenth century legacy.

These dichotomies resonate within the themes and images of this publication. Each image is in its way an optical extension of the 19th century 'Claude glasses', except that they suggest a concern with removing the glasses in favour of a less idealised view of the landscape, a view which embraces the incongruity and ambiguity of this complex and unique environment.

Karen Ingham
Co-editor and exhibitor, *HaHa · Margam Revisited*

no laughing matter

hugh adams

Nowadays landscape, like many other important things that we regularly contemplate, is a matter of 'framing'. I don't mean frame as in picture, for in terms of its importance that pales into insignificance besides other modern frames: that of the press photograph, the cinema, the personal computer, the television and even the car window. What we are allowed to 'see' is governed and predetermined by lots of circumstances, lots of people and lots of different motives. We may, for instance, be denied a particular view in the interests of simple privacy, or because what we would otherwise see is politically (or socially, or commercially, or environmentally, or militarily) unacceptable. Conversely, what we are encouraged to see is also shaped by the differing agendas of other people. You are encouraged to 'see', in the interests of higher sales of Hovis bread, for example, sometimes inaccurate views: the comfortable rosy-glow view of life in a romanticised late eighteenth or nineteenth century village, all roses rambling around rusticated cottage porches and neatly laundered peasant pinnies in abundance. Ignored is the reality: dirty pinnies, or no pinnies at all, rickets, the lack of anaesthetics, quasi-slavery and an unfair social system in general. And what of your olde worlde, mob-capped, gingham-covered honey pot? Does it come, as its price and gilly-flower graphics suggest, from a country cottage, with a hive in the garden, or from a vast shiny vat in a system-built factory on an out-of-town trading estate? And where, bearing in mind such things as budget-balancing and hygiene, would you really prefer it to come from?

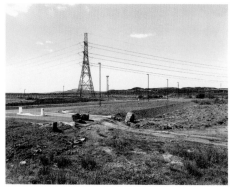

Richard Page, from *Spoilt*, 2002. Black & white print.

So, we know that what is suggested is not invariably the truth of the matter. When photographing 'sublime' landscape or a country scene, we know it suits us to avoid the visual blight of petrol stations or wrecked car dumps. We ensure our frame excludes such things that are inimical to our argument and only contains what suits our message.

What we 'see' in the landscape is equally determined by our personal cultural history and experience, as well as that special knowledge peculiar to each individual. For instance, I may view the life of an ordinary person in early 20th century Port Talbot as blighted, brutalised and quite possibly, prematurely cut short. From a greater distance, others might view such a life variously as exotic, folkloric, charming or even 'normal'. And those who experienced it in reality may have mixed views and may in hindsight recollect it favourably. Their attitude, equally lacking in objectivity, may be coloured by the remembrance of the ties of close family and community, religious comfort may be a factor, as may the security of feeling a sense of confidence that the future would be better than either the present or the past. In all these instances a variety of feelings may be engendered by exactly the same stimuli.

In re-visiting the past through old photographs we open ourselves to the reinforcement of happy feelings, or alternatively we may perceive something fresh and disabuse ourselves thereby of romantic illusions we may still be holding on to. When we consider any photograph, we would do well to remember that the meat of one person's nostalgia may well be another's poison. It is easy to simplify, romanticise or dignify the past and its people: time the great healer and all that. But it is as complex and contradictory as the present and we do ourselves no service if we emphasise either the rosy-glowness or the bleakness, at the expense of historical truth. To me the history of hereabouts has more than a little bearing on the present. It is fit to remember that one person's profitable wind-farm is another's visual blight. Remember too that those who object to developments of this kind from their executive dream homes in over-expanded villages, do so from properties that many other folk may equally object to on aesthetic and environmental grounds.

So then, in the midst of that great puzzle which is the modern landscape, the *ha-ha* is a clue; it indicates an illusion but it is a two-way one. It is itself a feature in a landscape which has been man-made, seemingly at the expense of the rich few but actually at the expense of the hordes who laboured physically to shape it and the even greater hordes who laboured to create the wealth of that fortunate few, so they could afford to have it shaped according to their whims. It is a feature in a landscape which has been man-made and man-manipulated on a massive scale. The irony of which is that the *ha-ha* was designed to enable the landscape to look more 'natural' than nature. The view was framed in order that it should look, according to the prejudices and tastes of the day, more picturesque than the natural one it replaced. Obviously only the rich and privileged were able to indulge in such conceits; they wanted the romance of nature rearranged according to prevailing fashionable tastes and were able to afford it. Ironically none of these landscapes achieved a mature state during their progenitors' own lifetimes. In the interests of this twilight romanticism, ruins were retained, rendered more picturesquely ruinous, or literally just built from scratch. 'Hermits' were employed. Their contracts exist: *"no shaving, stay away from the house, guests and of course, the pub; look picturesque: rattle your chains and moan a lot when walkers appear in the grounds, etc."* (Recently the National Trust advertised for a Hermit-in-Residence at one of its properties, with the usual strict conditions applying. There were over six hundred applicants!). Nature, in short, was wanted but not too natural a nature. Rusticity, in the form of animals, was desirable too, as were dairymaids to tend them and homogenised lovelorn swains. Hence the walled ditch (how much nicer

ha-ha sounds) keeping rusticity, in all its forms, sounds and — particularly — smells, at an appropriately ornamental distance from the house and effectively rendered invisible from drawing-room windows and terrace. But the reverse too was the case: the exquisite unsullied world of these 'Lords of Creation', although seemingly accessible to the villagers and those casual passers-by who had right to traffic their parks, was maintained at an unbreachable distance. The nobs existed within a spatial frame of mystery, otherness and untouchableness as, although through different devices, many of them still contrive to do. Karen Ingham gently parodies this in her series of photographs taken in Margam Park and Castle. The glance of the powerful from battlement or terrace now returned, ironically, by a girl with binoculars, perhaps one doing a school project, from the park. Her carefully assembled groups of people in landscape allude to Manet, Reynolds and Gainsborough, all of whom sent subtle messages in their paintings about the relationship between people and place. The artist's work underscores the message that it is the humble who dominate these spaces and vistas now, re-enforcing a major theme in this exhibition, the landscape is under new management, or, to quote one of the greatest Welshmen ever: *We are the masters now.*

But, as these modern photographs, often so painfully, show, *their* landscape — that of the masters of yesteryear, is now but one element in a much larger landscape. Some of *theirs* is subsumed into the one we now see and parts of *theirs* are even buried under it. Look at this new landscape. One might say look at *these* landscapes now: they overlap and there are far more than just one. How vast and open it all seems, but in fact the environment is as boundaried, fenced, closed, owned and controlled, as at any time in the last thousand years. And those who live and work here are as complex in their communities, clubs and sub-cultures, as the land itself. Often these overlapping communities co-exist peacefully, many are communities, in the nicest sense of self-interest, many are clubs — designed to be 'exclusive'.

Karen Ingham, from *Figures in a Landscape,* 2002. C-type print.

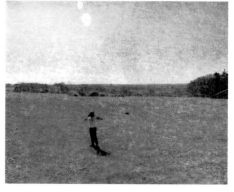

These are all types of modern village life, and the results of a different kind of enclosure movement. Now we have the community as fortress, with the porter, the video camera, the ansaphone, ugly guard dogs, the unsullied golf-club green, the security firm and the 'close', of pseudo-village executive homes. Maybe it is all this competing aspirant suburbanity which makes so many pine for the rule of taste of an aristocracy and emancipation from the dull uncreative horrors and pretensions of the nouveau riche. And now there are new wars: spheres of influence wars, wind-farm wars, wars over precisely whose countryside it is, wars which are at their most acute in places like this, where the town meets the country in complex, interesting, but often controversial ways. Is then this countryside the residual

indigenous villager's, the hunter's, the commuter's or even the tourist or the day-tripper's?

We *are* the masters now and all that lay within the well-patrolled, high fenced, robustly walled, ditched and ha-ha'd purlieus of the powerful is ours, well at least the local council's. That this is so at Margam is due principally to the vision and doggedness (and possibly not a little to the power-hungry perversity) of one of a new generation of noble lords, the proto 'people's peer', one local and ennobled, the ex-railwayman colleague of my former father-in-law, the Lord Heycock of Taibach. The estate is in common ownership in all senses and thus literally a 'People's Park' *par excellence*. But it is a puzzle *par excellence* too, as well as a pleasurable and painful problem. In Margam (and The Gnoll at Neath), the local authority, not a particularly wealthy one, is at once fortunate and unfortunate enough to own two of the greatest and most historically and aesthetically significant landscaped estates in the British Isles.

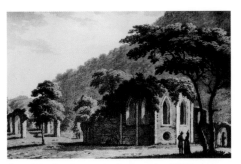

Anon, eighteenth century engraving showing remains of Old Margam House.
Image courtesy of Barry Flint.

How then can Margam be maintained and in what manner? Another and equally important question is: according to whose taste is it most appropriately maintained? There are choices, often irreconcilable ones. What, for example is permissible in the interests of economic viability? At which point in time do we 'fix' and restore it? This is the restorer's classic dilemma. Can one view it as historically and aesthetically appropriate to have a Tudor knot garden jostle with a medieval ruin, a Victorian castle, 18th century landscape features and all the gimcrack appurtenances of modern mass tourism? Well, apart from possibly the last and fortunately for us, it is both appropriate and possible. After all, the essence of Margam is that it may well be a jumble but it is a magnificent one, one which displays the successive phases of developments, in art, architecture and landscape, in particularly vivid and dramatic ways. But of the tourism: are we in our generation in danger of being viewed in the hereafter as having contributed to another form of exploitation and another layer of ruin? It is now an acknowledged fact that there can be too much success in attracting tourism, so that the essence of what is visited is destroyed. Similarly, there can be too much interpretation; even too much access to what might better be left as a mysterious and inaccessible ruin, or pleasing distant decay. Are not both, after all, highly symbolic? And these, in the larger landscape's even more complex competing interests, are among the easier questions!

We can look forward, I think with confidence, to a time when we shall hear arguments from historians and industrial archaeologists in favour of retaining blast

furnaces and those of the other structures of steel production which may have become redundant. Consider whether anyone who knew what we now know, would ever have advocated the destruction and filling in of Brunel's docks at Briton Ferry. Who would have thought that, apart from their strictly historical interest, their maintenance would have resulted in enormous economic benefit to the town and its becoming a tourist Mecca? Who would have thought it of *Big Pit* or that Blaenavon would become a World Heritage site?

So, just as I must question who am I to impose my aesthetic values on those who want a land flowing with ice-cream carts and hot-dog vans and one smelling of stale, fried onions, I also feel I have the right to object to those who want those things and suggest that there may well be other ways, locking horns with them, if necessary. Without wishing to suggest that it is appropriate to keep the built and natural environments in a deep-frozen state, in case in the hereafter they should come to have tourist potential, or historical, or aesthetic, or whatever, kind of significance, I do suggest that we should look at what may well become economic as well as cultural assets with greater care than has hitherto been the case in this and many other localities.

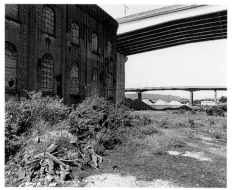

Richard Page, from *Spoilt*, 2002. Black & white print.

Today, the fact that a landowner could remove or destroy, an entire village in the interests of an unimpeded view (or, as in Margam's case, to construct a kitchen garden) is as universally abhorrent as was same village's removal again later to allow the construction of a motorway, the cheapest (and most visually offensive) route. Landscape-rape, seashore-rape, seascape-rape, townscape-rape, community-rape and people-rape: this area has had them all. And this is why I believe that the people of Neath-Port Talbot should have an absolute right to veto wind-farms, or whatever can be construed as further blight to their lives, even at the expense and danger of 'nimbyism'. This area in general has endured far, far more than its share of industrial pollution and visual blight, supposedly in the general interests of the British economy. The photographs in this publication demonstrate this emphatically, and the fact that the end of it has not yet come unambiguously. We must assert that, if we do recognise any value here in the Margam hinterland, this landscape is too special and now too fragile, to exist as a sandwich between wind generators and rail marshalling yards. There are many other possible sites for energy production; let other communities bear a share of aesthetic blight and inconvenience. The current spat over this issue is ironic, in the face of the fact that the evidence of both the will and capacity to restore is every where, both in this area with which we are dealing and in Wales in general and that circumstances have never been

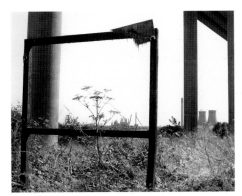

Peter Finnemore, from *Reading the Signs*, 2002. Black & white print.

more propitious for effecting a huge degree of change and renewal. We may not, in biblical terms, have either a continuing city or an abiding place but we are here, and are stewards of an unique and special heritage, expressed in local landscapes of unique and special complexity. It is this unique combination: of much-raped landscape overlying a dramatic geological base, and positively reeking of its multitudinous histories, which renders our inheritance so peculiar and so great. Now we can see, and the *HaHa · Margam Revisited* project is a great step towards our realisation of this, that it is the history of the humble, as much as that of the conventionally great, which is of interest and is indeed our principal glory. But we have also come to realise that the histories of the humble are frequently more heroic and actually rather more interesting than those of the great. And in looking at these photographs, I am reminded of all the victims of these landscapes and those who had them created. Not simply those who have suffered illness and abbreviated lives, as the by-product of industrial processes of whose inherent dangers we are in many cases just beginning to learn, but my classmates and childhood friends and neighbours, who drowned in reservoirs or canals or were lost in abandoned but unfilled mine-shafts. Of course, there are other, more subtle social victims.

In terms of opportunities to be found in the landscapes we have inherited we have the example of the city of Bilbao, which has so much in common with Neath-Port Talbot, in its topography, as much as its historic industry. Bilbao has done much to emancipate itself from blight and environmental pollution at least as serious as ours and is a world model for such. Its situation was equally the result of industrial decline, a decayed infrastructure, economic and cultural deprivation. Bilbao resurrected itself with a confidence that it was possible and appropriate to invest in cultural development as the engine for change. It developed an infrastructure based, at least initially, on architectural grand projects of such interest that opinion-leaders worldwide were forced to go to see them; 'quality' cultural tourism followed, with concomitant economic benefit. If Bilbao and Blaenavon, why not Margam? Our heritage, natural as much as man wrought, is a recoverable one and the *HaHa* project, which recovers something of our communities' histories and investigates their current relevance, is part of that process. Without exaggeration, it is possible to envisage the great house of the Mansel Talbots at the centre of renewal and again a vessel for the arts. Not this time (in the words of William Morris, who contributed so much to the embellishment of the Abbey Church) in order *"to satisfy the swinish luxury of the rich"* but to delight and instruct everyone, acting as a catalyst of social, cultural and economic focus.

Margam — Port Talbot — Neath — Swansea... from Stormy Down, on a clear day, when travelling west on the M4 — and it has always been the same, even on the old road — you get the most breathtaking view of the vast and unusual landscape that is the frame of this essay. In front of you is the spread of a huge and shallow landscape, its general shape, like a great grey half of an oyster shell sweeps and seeps and almost succeeds in enclosing the sea. This shell has strange pearls. And its centre is Swansea Bay. It is said that Walter Savage Landor compared it — favourably — with the Bay of Naples. This always struck me as improbable, until I actually saw the latter. Both bays are sublime and in both it is equally easy to discern the heroic resistance of strong dramatic landscapes to the depredations of dense transport systems and the foulest fruits of industrialisation. I spent the first twenty or so years of my life hereabouts and still when I return, always from the east, whether by train or road, I strain, looking right, for the first sight of the twin campanile of the Abbey Church at Margam camouflaged, as ever, by their residual mantle of green. It is only then that I feel as if I have arrived home.

Green too, improbably, is coming back. Everything is greener than I remember it, even though the opposite is supposed to be true. The fading of the evidence of coal-mining and the greening of the coal-tips through central Glamorganshire — behind me now — has created an ambiguous landscape, responsibility for which it is no longer possible to ascribe with certainty to either nature or the hand of man. Nowadays, the more you explore around here the truer this becomes and you can walk the inclines and defiles above the shore settlements and be uncertain of what is natural landscape, manipulated landscape, industrial archaeology, or land recovered from industrial blight. I remember a late-Sixties *Observer* article by Hunter Davies, about the narrow twistings of the former mining valleys, such as Maesteg, Pontrhydyfen and the Melyn, above Margam, Port Talbot and Neath. The

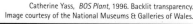

Catherine Yass, *BOS Plant*, 1996. Backlit transparency.
Image courtesy of the National Museums & Galleries of Wales.

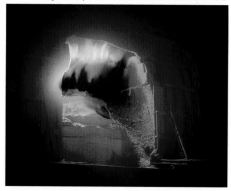

writer predicted the time when tourist coaches would be groaning their way through the restored greenery. Now it has become true. Not yet 'real country', whatever that should be today but that odd modern hybrid — a country park. This greening makes the shocking initial encounter with the Swansea Bay shorescape all the more surreal, and the devil is literally in the detail. The blast furnaces of the Margam Steelworks might have been designed by Max Ernst: many of the artists in the present exhibition, as we will come to see, draw out this quality of Surrealism. And indeed, particularly on a muggy day, of which there are lots, looking at it from the elevated section of the M4 — where it rips around the back of Port Talbot — you might still be in doubt as to whether what you were seeing was man-made or organic.

Ceri Richards, *Submerged Cathedral*, circa 1960. Oil on canvas.
Image courtesy of the National Museums & Galleries of Wales.

In essence the whole landscape is, like Margam Park itself, a contrivance, interfered with, manipulated and exploited, though, unlike the Park, mostly for short-term gain. And, as I say — raped — almost everywhere between the Rivers Kenfig and Tawe. It may be slowly greening now (some of the first experiments in removing industrial blight and retrieving possibilities of things growing from the ore-wasted, metallicised moonscape-landscape, occurred around here) and obviously more so in some parts than others but probably at no time since the time of the Tudors (when there was already coal mining here) has there been such tension between the pragmatism and utilitarianism of commerce and a desire to return it to an 'unspoiled' state. Historically, few landscapes anywhere can ever have been under such a peculiar combination of pressure. Always, even before it was the Roman *Via Julia Maritima* to west Wales, or became the pilgrim route from Llandaff to St. David's, it has been a transport corridor, if, for most of its existence, a rudimentary one. Its busyness and arguably, its sophistication, has accelerated dramatically with the advent of the M4, skidding through the landscape and the Inter-City 125s, hissing their way to Swansea. Neither railway nor motorway, strong though their presence is in the landscape, succeed in either dominating or defining it, for the landscape is too strong, too naturally dramatic and too riven with competing visual incidents, natural and man-made.

What you see from Stormy Down is pretty clearly divided visually, just as it is divided socio-economically and culturally in different permutations. Natural, pseudo-natural, man-manipulated and man-constructed also co-exist. And, not far beneath this precise spot, on which I am now notionally standing, is sand and quite probably a ruinous outpost of Kenfig beneath that. Kenfig, is the buried city and was the seat of a Celtic bishopric — the see beneath the sea! It was inundated, *they say*, by sand and sea in early Tudor times. It is also *said* that from below the waters of the Kenfig Pool, on wild, stormy nights, naturally, the bells of the submerged cathedral can be heard tolling. Can this have been Dunvant-born Ceri Richards' inspiration for his *Submerged Cathedral*?

Bernd & Hilla Becher, *Garw Colliery, Pontycymmer*, 1973.
Black & white print. Image courtesy of Schirmer/Mosel, Munich.

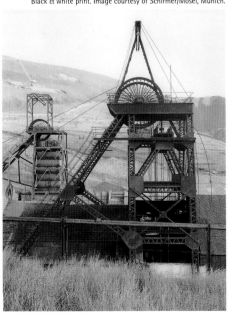

The moodiness of Gothic abounds: away to my left is Sker Point, defining the easternmost reaches of the bay. Once its long menacing spine stretching out to sea was an excellent aid to the wreckers who lured ships on to the inhospitable coasts of mid-Glamorgan. Sker House (the very word is like a knell!) was home to R.D. Blackmore's *The Maid of Sker:* more Gothic gloom you could not wish for.

From where we are, we can see sand dunes before us and the still visible ruins of

Kenfig Castle, struggling against the on-shore winds, sand and scrub, confront both steel-mills and the steel-hard hills. The latter are operatic, *Wagnerian* sometimes, in their drama. And, in turn, they confront another, improbable, by-product of steel. The entirely functional manipulations of a land and water-greedy industry have resulted in a large and unnaturally symmetrical lake. This latter-day Kenfig Pool, where pleasure boats bounce and sail boats scud frivolously in the squally weather, ignores the twin solemnities of looming steelworks and gloomy nearby crematorium, looking as if parachuted in from Scandinavia. This pool, a large element in the landscape, is predominantly utilitarian and the reservoir for Europe's biggest steel works, which drifts, surrounded by its satellite plants and marshalling yards miles and miles between seashore and town. Its blast furnaces have dominated land, sky, the lives of the populace and the imaginations of artists.

From Stormy Down you can see these works, juxtaposed with their exact cultural and aesthetic opposites: the equally man-made and manipulated, great works of art that are Margam Castle and the landscape of the Margam Estate.

This point at which I stand represents the last gasp of the expiring Vale of Glamorgan. This flat terrain before me, between the sea and the hills, is where, at Margam, the mountains make a determined move on the sea, literally narrowing transport's opportunities. They crowd communication routes and industrial development into what was a sandy, barely welcoming apron of land; the sand has never entirely been eliminated. And this land has for two hundred years been turned over and built over, in the interests of profit: profit deriving from some of the most unkind (to people, as to landscape) industrial processes that there ever were. It is a place of pretty epic Atlantic weather, often gloomy weather too. There are dramatic winds. These winds, driving in from the sea, mostly ensured that any pollution there was (and there was lots), stayed put, trapped between sea and mountains. A watercolour I have by Leslie Moore, of the building of the first bridge over the River Neath and the Briton Ferry of my childhood, shows the pollution — the same pollution as Port Talbot's — plainly. Do I still detect hints of salmon pink in Miranda Walker's Margam landscape photographs? But no such ambiguity in my day: salmon pink was the landscape, salmon pink the roofs and salmon pink the washing, on all the clothes lines between Mawdlam and Jersey Marine.

Old Margam appeared to escape the worst grossnesses of industrialisation, though old Margam certainly profited from it. The major mark on Margam, before the modern period, was made by Christopher Mansel Talbot. He it was who added

Leslie Moore, *Neath Bridge*, 1955. Watercolour.
Image courtesy of Hugh Adams & Rogelio Vallejo.

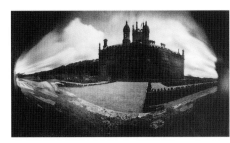

David Dixon, *Margam Castle*, 2002. Black & white pinhole print.

Wales' precursor of Gormenghast (its gothicness and moody gloominess never more brilliantly depicted than in David Dixon's pinhole camera photograph, the result of an artist residency at St. Joseph's School, as part of the *HaHa* project) to the looming woods and glowering hills, by having Thomas Hopper design and build Margam's fantasy Castle. He 'removed' the medieval village of Margam and constructed Groes, with its weird octagonal chapel on the town edge of his estate. Less controversially, he welcomed leading industrialists and thinkers to Margam. Isumbard Kingdom Brunel was one, both a business associate and friend. He also welcomed his cousin Henry Fox Talbot of Lacock Abbey, to the new Margam. The latter had played at Margam as a child and spent long and enjoyable summer holidays with his Mansel Talbot cousins at both Margam and Penrice. Fox Talbot was the inventor of photography and, like his cousin Christopher, 'Kit', later became a Fellow of the Royal Society. Margam thus welcomed some of the most important and inventive people of the age. Many were distantly related to the Mansel Talbots but some of the most important, particularly for photography, were members of the immediate family.

The relationship between the Lacock Fox Talbots and the Margam/Penrice Mansel Talbots was a very close one. Henry Fox Talbot and Kit were at Harrow together and were later M.Ps at the same time. They were in quite different ways, very modern men. Kit was a Victorian entrepreneur *par excellence*; his steam yacht was the first private ship to pass through the Suez Canal when it opened in 1869. He inherited a Margam estate which was barely solvent and at his death left over six million pounds. In 1873 he owned 34,000 acres of land with an annual rental income of £44,000 (these figures need multiplying by between fifteen and twenty to establish their value today). This fabulous wealth was a result of shrewd investment and an active life on boards of new enterprises, not least the Great Western Railway. As Brunel's friend and collaborator, he invested heavily in railways. When the English Copper Miners' Company built the first dock at Aberavon in 1836 they christened it 'Port Talbot' in his honour.

Miranda Walker, from *Glimpses and Fragments*, 2002. C-type print.

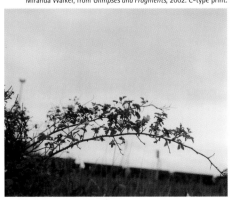

Coincidentally (and importantly for the arts at Margam), like the son of the second Marquis of Bute, another great South Wales aristocratic yacht-owning entrepreneur, Kit's son Theodore was a Catholic, church-obsessed medievalist and a dreamer, who turned the fruits of parental investment into art, architecture, vestments and landscape. There seem to be those folk who make it and those who spend it and, rarely it seems, are they the same. Kit Mansel Talbot however was far from being a mere mechanistic utilitarian and frequently berated his photographer cousin for

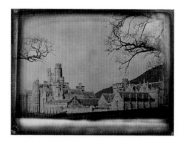

Revd. Calvert Jones, *Margam Castle*, 1841. Daguerrotype.
Image courtesy of the National Library of Wales.

being insufficiently 'an artist'. Indeed he, like a number of those in the Mansel Talbot family, expressed themselves quite forcibly that Henry Fox Talbot should use more discrimination and either choose more 'artistic' subjects for his Talbotypes, or work in tandem with a proper artist! One wonders what they would have made of Adam O'Meara's 'sun pictures', in which he exposes light sensitive paper to the chemicals and light of the steelworks? Their beauty and the colours, again brings Catherine Yass and Howard Hodgkin to mind. Possibly his implied criticism of environmental pollution inherent in the industrial process would have fascinated the Talbots too. Of their reaction to the implication for profits we can but speculate. Certainly the chemicals they used had adverse effects on them.

It was Kit who welcomed the Revd. Calvert Jones, another famous photographer, to Margam (where he took one of the best known photographs of the castle, reputedly the first photograph taken in Wales) and also gave Charlotte Talbot his daughter — herself no mean photographer, and a regular complainant about the unpleasant effects of photographic chemicals — in marriage to yet another accomplished one, John Dillwyn Llewellyn of Penllegare. A practical interest in photography seems to have become a positive family trait for, as photographic history shows, the name Talbot recurs in successive generations. But apart from Fox Talbot himself, John Dillwyn Llewellyn and, arguably, Calvert Jones, the precise relationships and extent of their activities, remain to be thoroughly researched.

So Thomas Hopper, this famous builder of no less than three Gothic Revival castles in Wales, built one for Kit and an unusually massive and ramified pile it is. Situated on an eminence above the place where his forebears had built (where the Orangery now stands) — and later demolished — a house, with materials cannibalised from the ruins of the dissolved Cistercian Abbey. Of the monastery, the nave remains in use as the parish church. The rest, including the beautiful chapter house, were

Adam O'Meara, from *Pollution Rose*, 2002. Sciagraph.

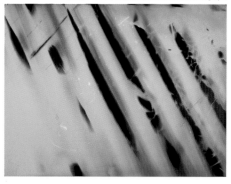

subsumed into the park and became 'picturesque' elements in the ornamental landscape, subsequently to be neglected, as fashion again changed.

Sensibility to the picturesque actually began in Wales, at Aberglassney with John Dyer. Aged sixteen in 1716, long before he became an Anglican priest, he wrote the poem *Grongar Hill*, describing his emotions in response to the nearby valley and hill, then with a ruinous castle. He had discovered that a ruined building could be more beautiful than a complete one:

And a certain disjointedness and moulder among the stones, something so pleasing

in their weeds and tufts of myrtle, and something in them altogether so greatly wild,
that mingling with art, and blotting out the traces of disagreeable squares and
angles, adds certain beauties that could not be before imagined, which is the cause
of surprise no modern building can give.

(In a letter, written from Rome in 1724)

This then is the culprit to be blamed for all the temples, serpentine-rills, gazebos, ha-has and grottos and *faux* ruins and framings of 'views' which followed and was responsible for much at Margam in succeeding generations, as Picturesque gave way to Neo-Classic and Gothic and Gothic Revival and real ruin, in turn.

Now, from the Abbey, a vast flight of steps leads up to the massive skeletal castle, all in the lee of hills whose upper reaches were, even in its heyday, denuded of their trees, lost in the interests of early ore smelting. This image of co-existent rural felicity, pseudo Arcadia and industry is piquant. In that respect it is just the same today: Hopper's castle faces the visually unruly ensemble before and (both literally and metaphorically) beneath it: an improbable, anarchic agglomeration of disparate elements as you could ever see. The castle presides — like a theatrically grim, fussy but on the whole indulgent, Victorian matriarch, aloofly surveying the post tea-party depredations of grand children on a large tablecloth.

Catherine Yass, *Coke Plant*, 1996. Backlit transparency. Image courtesy of the National Museums & Galleries of Wales.

But during all these fanciful musings I am still on the brow of Stormy Down. Greater contrasts than the views from here too are difficult to imagine. The strip mills and marshalling yards, dominated by distant and dramatic blast furnaces. To the right is an enormous sweep of agricultural land, culminating in the fir woods and the hills: hills where it i*s said* the Black Beast of Margam Forest roams.

This is a very modern landscape (it has after all a golf club and the 'Swedish' crematorium, surely indicators of a quintessential *sub*-urbanity?). Maybe the few leftover farms are modern hallmarks of that too; certainly suburbanity is more than just suggested by blots on the landscape in the shape of the newish housing. Epic insensitivity this: all from industrially produced building materials, with design typical of suburban anywhereville. What about the elevations, slate and stone, which would have enabled a more visually comfortable seat in landscape? Still, what I can see is very evidently the residue of a great ornamental landscape of which many original features remain and more are being restored. Once there was a great avenue, stretching two miles, from the ceremonial gates of the formal parterre garden of the first mansion almost to the sea. Now, punctuating the

scene, as if incidents on a vast model railway layout, I detect 'my' markers: the odd west towers of the Abbey, stylistically as displaced as the housing. Adding to the general architectural eccentricity, is the severely decorative corona-thing which is the dominating central tower of the castle, very high and a vague nod in the direction of Ely's Lantern Tower. Beneath is an enormous vaulted hall, reminiscent of the entrance porch of Westminster's Victoria Tower, or the 'Wills' Penis', at Bristol: mightily impressive, but like much else at Margam, defying accurate stylistic description. Margam though is not a 'proper' castle'; there was never one here, just two differently great monasteries, then two differently great mansions.

Again and again, one dwells on contrasts and contradictions, for, not only do we have contrasts between the industrial and semi-agrarian scenes but social ones as well. For where else is there such a diverse architectural pot-pourri as Margam, or one having such potential for re-invention as the major element in community reinvigoration?

A slight aside... it always exercises me why this is not a World Heritage Site (clearly it can hold its own with many of them), or why was it not acquired by the National Trust? Quite unambiguously what the estate contains is distinguished enough and sufficiently capable of income generation to satisfy the Trust's criteria, including an endowment guaranteeing self-sufficiency. May it be that it was on the wrong side of Offa's Dyke? It may also be that its escaping the National Trust — as endangered a species as this renders it — also enabled an escape from the homogenisation and sterilisation, which is so often acquisition's concomitant?

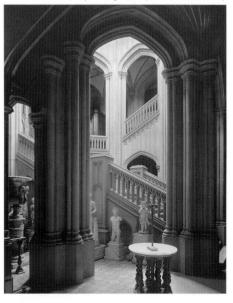

Thomas Mansel Franklen, *The Staircase Hall, Margam Castle*, 1891. Black & white print. Image courtesy of Cardiff Central Library.

Just consider what they failed to get: castle; lake and ornamental ponds; landscape, at least partially, designed by William Kent (with Repton and 'Capability' Brown, one of the three greats of British 18th century landscape design); farmlands and forestry; substantial and unique remains of a Cistercian Abbey; abbey granges; chapter house; orangery, the largest in Europe, if not the world (also by an architect of distinction); ornamental gardens with original features of the grotto and gazebo kind; a Neo-classical triumphant arch (the Four Seasons Façade, rumoured to be by Inigo Jones); the Stones Museum, beautifully designed and now maintained by CADW, with its superb and unique collection of pre-Christian and Early Christian standing stones, Celtic crosses and tomb slabs; functioning Norman Abbey Church, housing a brilliant Victorian sanctuary, a plethora of extremely distinguished monuments and memorials of various dates, glass by Morris and Burne-Jones and a collection of similarly distinguished liturgical vestments. Ha ha indeed!

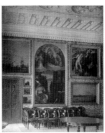

Spencer Percival Talbot Nicholl, *The Dining Room, Margam Castle*, 1895.
Black & white print. Image courtesy of Cardiff Central Library.

The direct Mansel Talbot line 'failed' in Miss Emily Talbot; her nephew who inherited Margam had estates to preoccupy him elsewhere, so eventually it was sold. A patchy succession of ownership, the usual wartime incarnations and no doubt depredations — think Brideshead, or worse — resulted. So out went the Mansel Talbots and at the 'Great Margam Sale' of 1942 (can there have been a worse time to sell?), out went much else, including Canalettos, a Rubens and a Veronese, In came new-er, money, in the shape of a brewer baronetcy, recently created, with money made from mineral smelting and brewing in the Neath Valley. Financial circumstances, at any rate comparative to the predecessors, were more reduced, so the castle itself was not occupied: they lived in the former land agent's house, Twyn-yr-Hydd, which can be seen in one of Matt Pontin's photographs. The castle, in not uncommon manner, fell into disrepair. Rehearsing the attempts to find a use for a building which by the fifties was expensive to upkeep and deeply unfashionable, would be tedious. The upshot was several heroic attempts to give it away. Sir David Evans Bevan, unconsciously attempting to further Theodore Talbot's earlier dream, even offered it to St. Michael's College, Llandaff as a seminary. All failed. Eventually it got too much; the Baronetcy decamped to that most suburban and surely unbaronial, of places, Jersey. Decline and fall... Margam got too hot. As literature alone attests, this is an almost classic tale, for as with many estates owned by those who made vast fortunes from agrarian and industrial exploitation of people and environment, it was abandoned. Sometimes this happened when the products became unprofitable but more usually, because industrial processes, or their by-products, which were the source of the wealth, got too near the *ha-ha*. Some became institutions; asylums, isolation hospitals and orphanages were favourite uses but Margam largely escaped that fate. Eventually, as at the Gnoll (though with less disastrous results than for that house), the much derided, good old public sector and this too is a frequent pattern, rode to the rescue. The people, in the shape of the then Glamorgan County Council and subsequently West Glamorgan County Council, acquired the estate. This today is in the hands of another successor authority, the Borough of Neath Port Talbot. Aberrantly, the 'traditional' fire, which seems so frequently to play into the hands of the would-be property developer or owners embarrassed by listed but unsaleable buildings, occurred at neither place when they were in private hands. The Gnoll, at least externally not a very distinguished building, was repeatedly razed for practice by the fire brigade in the late-Fifties and only outline foundations remain. Less drastically but as unfortunately, Margam Castle was burned as the result of an accidental fire, in 1977 when its restoration was already well underway.

Margam Park, Port Talbot and The Gnoll, Neath! What odd dowries these two local

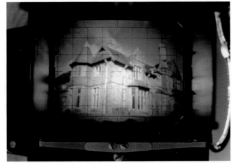

Matthew Pontin, from *Resurrected Landscapes* (Twyn-yr-Hydd), 2002.
C-type print.

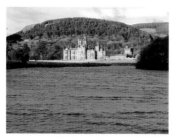

Anon, *Margam Castle*, 2001.
Image courtesy of Neath Port Talbot County Borough Council.

authorities brought to their recent 'marriage' and what an encumbrance they must almost certainly have seemed. Magnificently fortunate dowries too, which must now be regarded as quite palpable assets. Happily recent scholarship, greater affluence and a reappraisal of their value, is leading to the recuperation of many of the historic ornamental landscapes of South Wales. The Gnoll and Neath of the Mackworths was the very crucible of the early industrial Revolution, just as the Margam and the Port Talbot of the Mansel Talbots was central to later developments, including photography. So there are very many reasons, apart from their beauty as landscapes and internationally seminal positions in the study of ornamental landscape, that they must survive, and be sensitively treated.

Revd. Calvert Jones, *Kit Talbot & Family*, circa 1843. Black & white print.
Courtesy of the Lacock Abbey Collection at the Fox Talbot Museum.

Coincidence abounds. The early history of photography saw Margam as one of the confluences, not just in terms of its aesthetic development but its technical and scientific progression too. Interestingly Margam's subsequent history, essentially one of progress towards greater democratisation, coincided almost exactly, with similar developments in photography that most accessible of creative processes (and arguably, the most democratic art form of all). The two Talbot cousins, Kit and Henry, were also a quite remarkable coincidence: archetypal 'Eminent Victorians', they combined a commitment to the arts and humanities with cutting-edge scientific and technological achievements, in any number of fields. Kit appears the more conventionally practical, which accounts for the vast increase in his wealth. Henry, it appears, was more concerned with knowledge for its own sake. He had to mount serious retrieval operations, on a few occasions, when others claimed and began to capitalize on inventions which were essentially his. H.J.P. Arnold's account of these, in his cumbersomely titled book: *William Henry Fox Talbot — Pioneer of Photography and Man of Science*, pictures him as somewhat otherworldly, at least in his business dealings. Henry Fox Talbot refers lovingly to his childhood visits to Margam and Penrice Castle on the Gower peninsula. On the whole the family at Margam seems to have been fairly enlightened, for their time, but none of them, however 'socially aware', plausibly emancipated themselves from notions of *"the rich man in his castle, the poor man at his gate"*, or of God having made things that way and *"ordered their estate"*!

My mother told of, when very young, having to curtsey as the carriage bearing the daughters of the Earl and Countess of Jersey (and Mansel Talbot relatives) passed by, en route for a Sunday School prize giving at St. Mary's Llansawel, at which the very superior persons distributed books and no doubt improving tracts. This was the pivotal point of social change, at which a society was becoming less green, in

all senses. The grime and I'd like to think the politics, saw the withdrawal of the real nobs to less compromised ruralism and better insulation from the grosser aspects of their wealth, leaving their works and their rental income in the hands of agents and estate managers. These continued to bask in aristocratic connection and supposed reflected glory, well into the twentieth century. Increasingly, they had to cope with new realities: the rise of socialism and a critical population holding notions of education and healthcare as a social right, not charity and a much less biddable and compliant workforce. What principally distances us now from the rapidly modernising society of a hundred years ago, is the difficulty of reconciling the seeming modernity of an industrial-scientific enlightenment with all the residual social trappings of feudalism, as typified by that curtsey.

All these contradictions find expression in photography. When we examine its history, we face the main dilemma of interpretation: the obvious paradox inherent in the sepia and the rosy-glow factor. We also realise that photographic history is inextricably bound to things connected with Margam and the two remarkable branches of the Talbot family. Their histories, their marriages and dynastic relationships, are well known, They are visible indeed, in the great works of art and architecture that they commissioned over many generations. In private there were the paintings and sculptures of them adorning their many houses. In public we see abundant evidence of their glory, grandeur and seamless self-esteem: the coats of arms on their carriages, banners, gate-pillars, and particularly in 'their' churches, those they inherited and those they built. They were closer than ordinary mortals to God. Indeed, they positively forced themselves on 'Him' as of birthright, in their positions in church while living and their positions in church when dead.

But now these public memorials are misunderstood, if considered at all. I realise, as I look for illustrations to accompany this text, just how many there are. In the many local history books are thousands and thousands of photographs of ordinary people and their landscapes. I ask myself whether all communities, particularly working-class ones, are as well-documented as in Neath-Port Talbot? I realise the paradox: that it is the documents of the anonymous mass which have survived and are of vivid interest to those of my children and grandchildren and pored over and speculated about, in ways that those of the nobs are not. I find a photograph of my grandfather, James Adams, taken in front of a carriage, as he stands in a group photograph of men about to go on an outing. Another I recognise as being of a former neighbour, others of boys from my school. There are photographs that I absolutely know will have people that I knew in them. If only I could find a

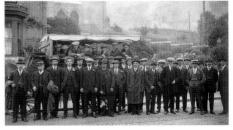

Anon, Briton Ferry men gathering for a pre-1900 horse-drawn outing. Black & white print. Image courtesy of David Roberts, Memory Lane N&PT.

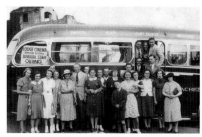

Anon, Staff of the Lodge Cinema, Briton Ferry, 1939.
Black & white print. Image courtesy of David Roberts, Memory Lane N&PT.

magnifying glass; they are small, pale and indistinct, almost ectoplasm people! How very different it will be for my grandchildren, who already have thousands of photographs of themselves and will have family photographs going back many generations. I have few photographs of my grandfathers and parents and none of either grandmother. I have though seen the photograph of a lady, my grandsons' great, great, great grandmother Thomas. She would have been a contemporary of William Davenport and the Right Honourable Lady Theresa Fox Talbot of Laycock, Henry's parents, and she is now rather less anonymous than them. Her picture was taken outside her house (well, the Earl of Jersey's actually), Barn Cottage, in Briton Ferry. She would have been one of the earliest working-class people of whom there would be a photographic record.

Emmanuel Cooper, in his book *People's Art,* which is the first comprehensive survey of visual arts activity of the British working class, quotes from Dickens' *Great Expectations.* Its main character, the orphan boy Pip says: *"I never saw my father or my mother, and never saw any likeness of them (for their days were long before the days of photography)..."* Cooper points out that Dickens was *"identifying a major difference between rich and poor and the vital role of photography in providing likenesses which could so significantly shape experience and memory. As commercial photographers started to offer relatively low-priced images in the second half of the nineteenth century, so the less well-off could record their appearance, enabling them for the first time to acquire a visual history."*

Clearly the aristocrats embarked on having their own and their properties' likenesses taken with some abandon. Certainly it was a long time before the technology allowed it but eventually they learned to smile to camera and relax. The initial failure to do so was a characteristic which embraced all social classes. It is particularly interesting to study what humbler folk began to do with this new tool, but important also to remember that it was a long time, indeed not until a while after the Second World War, when taking photographs themselves was affordable by ordinary working people. Before that family photographs in particular meant an inhibiting trip to the studio and still no smiling.

The uses to which photography has subsequently been put are legion. It has been used as an artist's medium, it has been used to record and it has been used as an agent, in order to achieve social and political change. Overwhelmingly, its most popular purpose has been to act as a celebratory record, for the tendency, in this country at any rate, has been to record happy occasions, not sad.

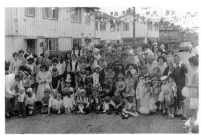

Anon, Newton Avenue, Sandfields celebrating the Investiture, 1969.
Black & white print. Image courtesy of David Roberts, Memory Lane N&PT.

During the time which elapsed between the possibility of photography and its use by even affluent middle, let alone working-class, photographers, photography was done *to*, people, rather than *by* them. It was not until equipment came down in size, as well as price that it really became available to non-professional ordinary folk. Unlike the Mansel Talbot family, the vast majority of their social inferiors took a long while to concern themselves with the aesthetics of the business; basically they were simply interested in recording and celebrating. And of course what was recorded and celebrated was overwhelmingly the familiar, not for them the exotic locations of their social superiors as subjects, nor the luxury, for the most part, of the technical experimentation of the more privileged. But by the early 20th century photography was notionally in the hands of everyman, even if the less privileged would only have access to fairly rudimentary equipment for another fifty years.

What they then did with it you can see and it is as rare indeed to know the photographer's identity, as it is to find great originality in the subject, for there was no pretension to the photograph's being 'art'! Unless there is identifiable information on the back one never knows, and generally that scrawl tells us more of the taken than the taker. What was done to the working class was more interesting on the whole than what was done by them. But again the 'framing' of official photographers, the press and freelancers, tended and continued, for many years, when confronted with the subject of the lower classes, to confirm clichés, rather than be investigative or document reality. It was only after the Second World War that either photography by, or of, the humbler classes became at all sophisticated, when equipment fell in price and improved in design and portability.

I would argue that it is many years before we see images that have other than technical or *mere* historic interest. The emergence of skilled, if unwitting, social documentarians in the fifties, gave way to more self-conscious employment of the camera to produce Art. Only a little later, was it used consciously and pointedly on any kind of scale, to make social and political comment. Gradually we recognise the rise in awareness of the camera's, but in reality the photographer's, power. At the time when such phenomena as the Mass-Observation Unit had done its work but not really registered on the consciousness of the working classes, there is evidence of a natural awareness of the importance of a photographic record and those seen protesting, over council rent rises, or striking workers, for example, made sure there was a photographer, as well as a reporter (sometimes the same person) from the *Neath* and *Port Talbot Guardians* and also had the savvy to pack the frame with 'respectable-looking' protesters.

Of the billions of photographs that have been taken in the last hundred and fifty years, only a very small proportion is in absolute terms interesting. Like the photograph of my great grandmother, many are dull, over-exposed, badly composed, tiny and totally banal, yet this photograph has been the focus of an enormous amount of interest, on the part of her contemporaries and their descendants and it has been the repository of nostalgia, and not inconsiderable love. Love far more and more spontaneous, I'm sure, than the stilted conventional clichés gouged out on the tomb-slabs and cartouches of her supposed betters.

As one gets older one remembers more, not less, of one's childhood but memories are fitful and sporadic, spurred by coincidence and patinated with a sadness, for which sepia is entirely appropriate.

Looking at photographs in researching this essay has brought so much back. I realise that I actually hated all the conviviality, the forced mateyness of the street trips, generally to the nearest town on the other side of the border with a pub open on Sunday, and the street parties. Fifty years on, it is saddening but very interesting, to see these recently commissioned photographs, such as Chris Dyer's, in which the celebrations for the Queen's Golden Jubilee feature. The dispossessed continue to celebrate the triumph of those possessed of everything: it is this, rather than conventional nostalgia, which makes me sad.

Despite all its bleakness and maybe because of it, in our street they developed a positive fetish for street parties: the war-end ones, the various V-something Day ones, which I was too young to remember (I know them, of course from photographs). Then I appear in the photographs, fading and diminutive, dressed like a little man and in a tie by the age of nine. We weren't rich and these may have been taken by a relative affluent enough, there were some of those, to afford a camera and the cost of developing. More likely, it was taken by someone who 'went round the doors'.

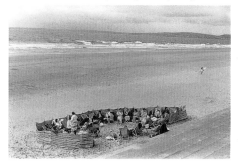

David Hurn, *Aberavon Beach*, 1968.
Black & white print. Image courtesy of Magnum Photos.

Incidentally, I don't really think all this street partying was born of any particular monarchism, or loyalty. Far from it; these were sentiments which were in satisfactorily short supply in my neck of the woods. So all that street partying was, as I suspect and hope, like today's: an excuse for a knees-up and in what was still a bleakly austere post-war time, a reason to party. The last old-style street party I remember was still in the Fifties. I can recall it vividly: the small, fabric 'redwhiteandblue', breech-clout-shaped flags that strung across the street had changed. Now they were sharp little plastic ones and I was kept awake all night by their hard edges

Josef Koudelka, *Sandfields, Aberavon*, 1998,
from *Reconnaissance*. Black & white panoramic print.
Image courtesy of Magnum Photos.

clattering together in the nervy breeze from the sea. I don't remember the year, but it was the "WELCOME HOME TESSIE: OUR FIRST G.I. BRIDE" (as the legend, painted on a whitish bed-sheet and strung between the telegraph poles, said) party and someone dropped a lighted match into the cardboard box holding all the fireworks and they all went up together.

As I'm more or less wearing my politics on my sleeve, I wish I could say that they don't have street parties (or carnivals, or street-trips) like that anymore but they do: Q.E. II – Jubilees 1 & 2, *very* retro and more rediscovery than re-invention. And Chris Dyer's photograph brings it all back to me. It is a skilfully composed depiction of a further step in the continuum of fiestas in a cold climate – the celebratory bunting vying with the jollity of 'road closed' tapes and phone lines. But generally community expression now, which might well be seen as a latter-day mixture of street party and street-trip, is more likely to be the stag-party or, even more violently, a hen one and the vomitarium now more probably Amsterdam or Dublin, than Ross-on-Wye or Craven Arms. *Break for the Border* then would have had quite different associations: a dry-Sabbath breaking trip to the nearest pub in England by our street's men folk and their, ostensibly, long-suffering wives and no Sunday School for us!

My memories of the trips, the carnivals and the street-parties are in colour, even if it's monochrome images which trigger them. Oddly, I feel most of my life was, until very much later on, in black and white as (if tinged with pollution-pink) was the place where I spent it.

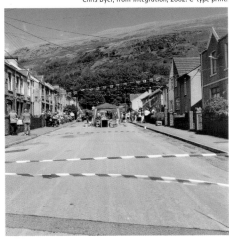

Chris Dyer, from *Integration*, 2002. C-type print.

Black and white photography renders working class subjects grimmer than actuality, as does selective framing. I dislike Koudelka's *Sandfields Estate* photograph for its melancholic, monochrome focus on the cliché. It is a formal composition, tells nothing of the terrain, or its society. How unlike David Hurn's famous one of the rain swept beach at Aberavon, with its families huddled behind a circle of wind-breaks, which has been seen the whole world over. Maybe I rented out those very windbreaks, for at the time I worked for Aberavon's first ever 'beach manager', red-coated Graham Jenkins (Richard Burton's brother), hiring wind breaks and deck chairs on the prom, by the 'Sunken Continental Tea Gardens'.

That the landscapes of many working-class housing estates is grim and bleak owes little to the folk who live in them and everything to the bankrupt imaginations, social prejudice and lack of imagination of those who planned them. The revelation

27

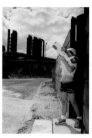

Tatjana Hallbaum, from *Westend*, 2002. C-type print.

of such grimness *pace* Koudelka, does not *per se* result in great art, nor compelling, or even interesting, photographs. I prefer to think that photographs taken in such places can contribute to change not despair, and consciousness-raise in other ways than merely point to the bleakness, which is obvious and which can also be exaggerated by such devices as the chosen lens, camera angle and even the weather at a particular time. Take the purely documentary photograph of Sandfields' new Methodist Church. There are those I know, who objected to its Mondrian-like colours as inappropriate to a place of worship but to me it says something of the human spirit's determination to strive against great odds, in order to effect environmental improvement renewal and change. Bernt and Hilla Becher, also internationally famous photographers, managed to reconcile an unvarnished depiction of post-industrial reality and yet celebration of the robustness of its forms, in their series of 'industrial typologies' of cooling towers, colliery winding gear and, yes, blast furnaces. Their *Blast Furnaces at Port Talbot* and *Garw Colliery* transcend the mere depiction of industrial grimness and celebrate the structures' formal beauty. I have written about these furnaces' reminding me of Max Ernst's work but yet another art/blast-furnace analogy might be between the works of Howard Hodgkin and the photo lightbox works of Catherine Yass (now, like the Hurn photograph, in the collection of the National Museum and Gallery of Wales) made of the steelworks at Port Talbot. These, even more conventionally celebratory, come pretty near total abstraction. Their colours are edible, their formal beauty undoubted and they convey the essence of the industrial process in works of complexity and some grandeur.

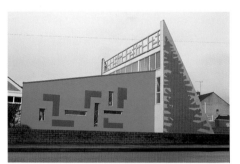

Shaeron Averbuch, Methodist Church, Sandfields, Aberafan.
Photograph by Marc Rome, courtesy of Cywaith Cymru.

How is it that this place has, if sporadically, for over a thousand years stimulated so much art? I have not lived in the vicinity for over thirty years. When I did galleries and museums were distant places, hard of access, particularly for those, like me, with no means of transport and no money. There were no public art projects and none of the artists-in-schools 'residencies' which exist today. As I write I am mindful of the large amount of artists' activity occurring now in this area: schools workshops, public art commissions and an abundance of 'outreach' projects. Equally surprising to me, and gratifying, are the considerable number of people I meet, artists and curators, who have come from and also returned to these communities. I note such things as cultural 'enterprise' and 'engineering' as late coming to the area. Even today the nearest mainstream art galleries are, to the west, in Swansea and to the east, in Llantrisant and Cardiff, but awareness of the potential of culture as catalytic in socio-economic regeneration is high and rising. The provision of public art using the expression in the widest possible sense, feeds

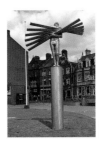

David Annand, *Order & Chaos*, Port Talbot, 2002. Stainless steel sculpture.
Photograph by David Symonds, courtesy of Cywaith Cymru.

the educational needs of the community in subtle ways. It is also (as Bilbao shows) conducive to massive regenerative and a higher quality of life for all. The effects of just one good artist's residency on a school, one well-organised public art commission, however modest, on individuals and the community is incalculable and can resonate for those affected by it for the rest of their lives. The possible advent of the National Centre for Photography in Wales at Margam is surely welcome for all these reasons. Not only would the use of the Castle at Margam in this respect help fill a pronounced gap but also possess these wider resonances, economic and cultural, as well as having enormous historic appropriateness.

I feel that it is the contradictions and contrasts that I have touched on above which have been so conducive to artists' activity here. Not all improbable juxtapositions are painful and perhaps surprisingly, least of all is the curious confrontation between the country and the town that we have here. Is it not its aesthetic dislocations in fact which makes this place so very special?

Something of this specialness has been made vivid by *ha-has,* so much so that it vividly underscores the irony of the project's title. These photographs are not the pictorial equivalents of architectural follies in landscape, nor are they divisive in the sense that the *ha-ha* as a landscape feature was. They are inclusive, constructive and socially empowering - some act like acid and are corrosive in their capacity to identify and etch the social foibles of these communities into our, as ever, resistant consciousnesses. They are not the products of cynical or manipulative artists, imposing another form of exploitation. And cruelty, if cruelty there be, is in the cause of kindness. Photographs like Miranda Walker's or Karen Ingham's, despite having the misty quality of post-Impressionist painting, are in fact rock hard in this respect and confront us four-square with the reality, social and environmental, of the local landscape now. It is done, as in the case of Tatjana Hallbaum, intelligently, allusively and without cruelty. The works of Richard Page are harder and much more direct in their confrontation. He shows us an abused land. Indeed, not for the first time I am reminded of *The Waste Land* when looking at photographs of these marginal country/town interface places. Page does not do what Koudelka (to my mind cruelly) did and neither manipulates, nor romanticises the blight. Oddly, there seems a large degree of correspondence with Peter Finnemore's images, which is not borne out by greater scrutiny. There are the same dreary monochrome wastes, which could in fact be on the margins of any UK town and indeed on the margins of any post-industrialised settlement the world over. But when we consider the detail we realise his present work has more in common with the Bechers': we in

Peter Finnemore, from *Reading the Signs*, 2002. Black & white print.

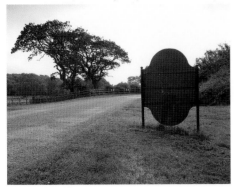

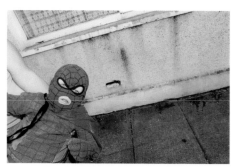

Tatjana Hallbaum, from *Westend*, 2002. C-type print.

fact have a sustained typology of advertising hoardings and public signage, all viewed from behind. To a great extent the objectivity of Page's wastes vanishes in these images and there is a misty ambiguity, more reminiscent of Finnemore's earlier autobiographical *Gwendraeth House* series. Behind such structures are murder done, as well of course such traditional folk activities as abandoning cars, variegated rubbish dumping and different forms of sex, licit and illicit.

The Go-between told us that childhood is another country. Well, mine certainly was, though it had an abrupt end, and there was, it is true, little order — at least in my recollection. My contemporaries, no doubt as infected as I, by gentian violet on elbows and knees and the abundance of Second Feature Western B-movies (in the interests of which I did much sniffling and grovelling, to persuade my Auntie Doris to let me go with her to the Palace Kinema, which we generally did every Tuesday and Saturday, for many years, until it went the way of all bingo halls), habitually galloped around tarmac-ed playgrounds, navy blue gabardine macs, single-buttoned at the throat, yelling 'hi' and 'howdee' and slapping our thin shanks, for all the world as if we were in Tucson, Cheyenne, or Wyoming but never Briton Ferry. This cultural displacement seems to have extended itself generationally and the fruits of Fifties cowboy culture persist to this day, if only in the frequent local greeting 'Hiya', or, more usually, "iya-a'. Tatjana Hallbaum's photographs show that this form of cultural elision persists and that the local *penchant* for the fantastic is undiminished. My contemporaries' children, and grandchildren by now, are something in space, nintendo slaves or, as the photographs show, some modern species of caped crusader. As for those who have ready access to neither privilege nor fantasy, the boredom, as Hallbaum shows, is plain: teen and pre-teen boredom is excruciatingly well delineated.

Landscapes, are not, as psychology and pop songs tell us, confined to those we can walk in. That there are those of fantasy we well know, as there are those of dream. Tatjana's 'Spiderman-child' will return to some kind of reality, prosaic or not and will thus be able to progress physically through most of the landscapes I have been dealing with. Via different mediations, Matthew Pontin takes us through a non-physical barrier, to a landscape through which we are not able to literally move, one of the mind; though for those who experience this, it is no less real. The word mediate is useful. The actual landscape and buildings, and all the clichés through which they are represented, he calls into play, using the most modern technology. There is a piquancy even in this. He moves us, physically and mentally, as he conveys the kitschness of much of this representation. Now this is something many artists

have done — to celebrate, or ridicule — kitsch. But here there is a much more serious intent than is usually the case and one that has very great import for this place and how it will in future allow itself to be presented and projected. Literally and movingly, he himself projects it to a woman living locally, affected by agoraphobia. The chapter house, the castle and their landscapes are introduced into her sitting room and through a variety of reproductive devices, organically incorporated into her life and experience. Not for the first time, one is obliged to speculate concerning just where 'reality' resides.

Today the steel works, rather than castle, abbey or parkland, which are the conscious *leitmotiv* of local lives and which dominate my view from Stormy Down. And what of them? Is it in fact conceivable that — like some reappraised industrial structures — they will in time be considered a work of art, architecture or engineering and be preserved forever? Certainly if they ever vanish and their monuments are required, they will exist abundantly. For it is abundantly plain that they have acted as a considerable stimulus, for artists and non-artists alike. They have metamorphosed as much as the Park (first the Steel Company of Wales, then the British Steel Corporation and now the unloved and unlovably named, Corus), have been variously valued, resented and even hated. Any number of members of my family worked there. My Uncle Roy did; he was a Labour Councillor and also Mayor of Neath (another uncle, in what seems an epic piece of no-hope futility, was the Conservative Party Parliamentary Agent for Aberavon). My youngest brother had a holiday job there during his university vacations in the Sixties or early-Seventies and told barely credible stories of young workers dropping acid, in the modern sense, in the strip-mills. Ironically, Philip, my other brother, later became Health and Safety Officer for the same company and would clearly have taken the very dimmest view of such activities!

Matthew Pontin, from *Resurrected Landscapes*, 2002. C-type print.

Maybe wrongly, I chart the decline in community and all the solidarities of Socialism, the Co-op and the Chapel, from the arrival of those works. Unwonted wealth engendered a sad materialism: flashy-shoddy cars unaccustomedly abounded, and cars were longer in some cases, than the frontages of the houses where their owners lived. Working class cultural institutions, many of them unique to south Wales died, as did enchanting small local cinemas and cafes, to be replaced by the now ubiquitous bingo halls and burger places. The residue of this decline and its successor, economic decline, are well-delineated in this publication, which contains images of settlements and people which the affluent south of England would prefer to forget.

And the myth is carefully engendered that the blight of these communities is somehow the fault of those who live in them. History proves otherwise: that people do not tend to thrive in poisoned air; or in the absence of a capacity to buy decent food. People do not tend to thrive when they are trapped in circumstances which allow no escape. This is why community solidarity fragments and vanishes, why *How Green Was My Valley* gives way to *Twin Town*. This is why 'street trip' now possesses different connotations and the drugs raid becomes far more a feature of life than the street party. It is a recognised truth that some of our communities contain some of the greatest deprivation in Europe.

What these photographs show are the reality, metaphorical and actual, but photography alone is not enough. That is why the artist's intervention in making photographic images is crucial. The 'folk' photograph which abounds, is nothing without Art to give it bite. Many years ago, I remember seeing in the *Neath Guardian* the photograph of the then Duke of Beaufort riding to hounds with the Banwen Miners' Hunt, which then had miners in it. Gratifyingly democratic, one might think. But what the photograph cannot show, in the absence of Art, is the landscape's complexities, or that the Duke owned the land on which they hunted, that he owned the substances under it, which they had mined: in essence, he, as had his forebears for centuries, to all intents and purposes, owned *them*. For the last hundred years artists, using photography have altered our perceptions of the world, helped to end wars and otherwise changed history. Occasionally they have collaborated, as with the pupils of St. Joseph's School, to share their skills and provide a different window on the world and to engender changed attitudes and a changed society. It may be that it is the camera above all else that enables us to assert that *We are the Masters Now!*

Hugh Adams, born in Neath Port Talbot, received the most important parts of his education there: at Briton Ferry Public Library, Brynhyfryd School and as storeman, postman, milkman, trench digger all over the borough, with summertime stints renting deck chairs (and windbreaks) at Aberavon Beach. His mother was Theatre Sister at Neath Hospital; his father's office was in Port Talbot, where both brothers worked at the steel-works. Chair of Cywaith Cymru · Artworks Wales, he is an internationally published writer on the Visual Arts.

plates

miranda walker

Glimpses and Fragments With glimpses and fragments of landscape these images reflect my impression of the uneasy environment both within the Margam Park landscape and around it. Whilst the industrial workers from the degraded landscape below can now wander freely in the park, the fine house and grounds still speak loudly of privilege and separation, of barriers of class and position; but most powerful of all is the overriding presence of the Port Talbot steel works and their service activities, whose own barriers, fences and padlocks, and whose noise, stench and billowing pollution informs every aspect of their surroundings.

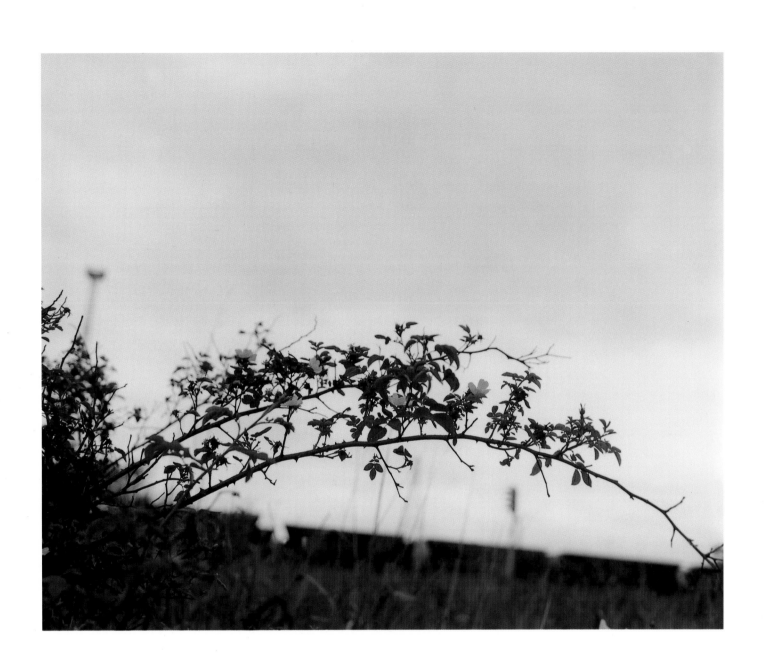

peter finnemore

Reading the Signs Port Talbot. Tai Bach. Margam Park. Briton Ferry. Baglan. This is a landscape

containing a proliferation of signs, from billboards, hoardings, signboards, highway signs. They are

public, visible, strategically placed and compete for attention. They function as sites of communication.

Through text, images and universal symbols, they offer different degrees and qualities of information.

This is the public, official and conventional face of signs. By photographing the backs of signs, their

information is withheld. These concealed spaces can reveal marginalised social spaces, or disclose

details that have been hidden from attention and bring them into visibility. They become something

other than signs. They become symbolic signs and collectively speak about the different qualities

and layers of the social, cultural, historical landscape they inhabit.

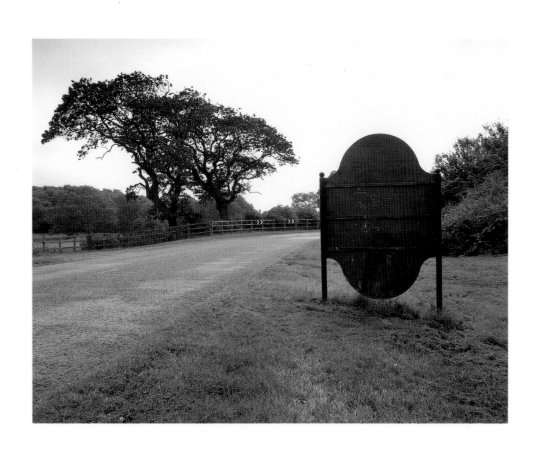

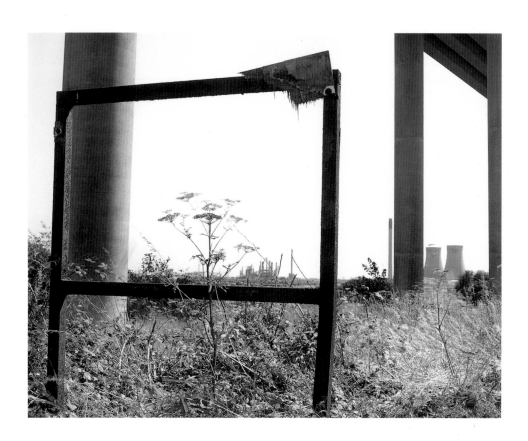

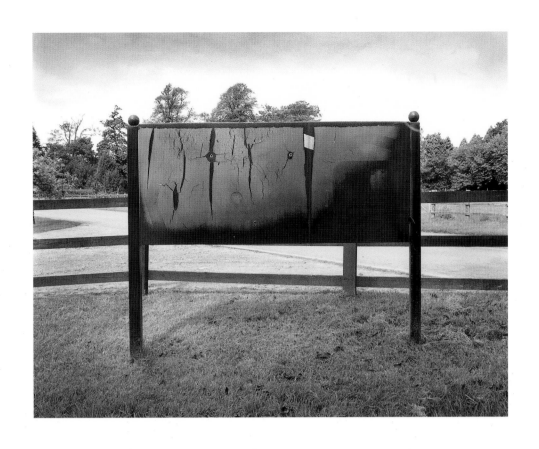

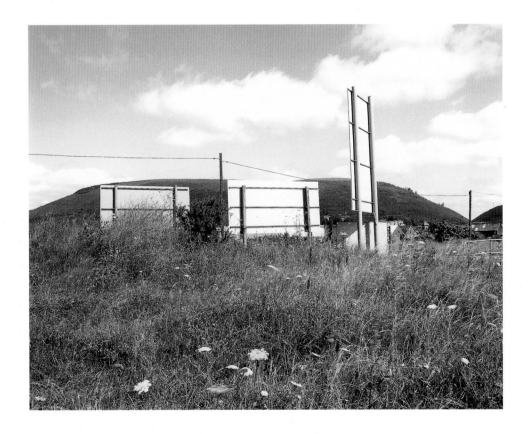

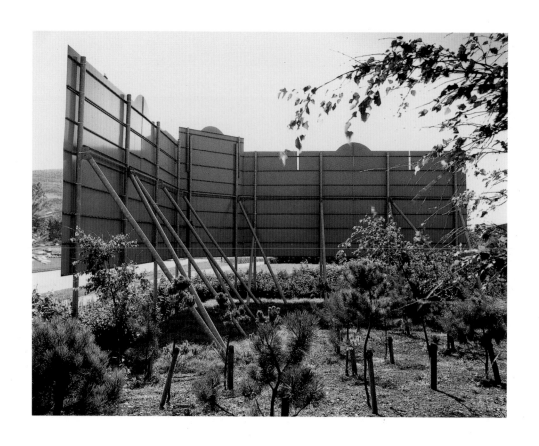

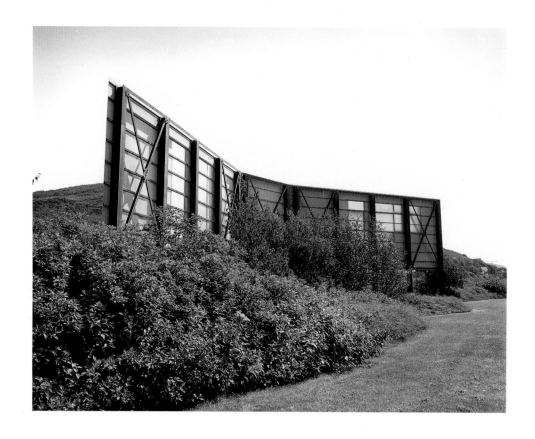

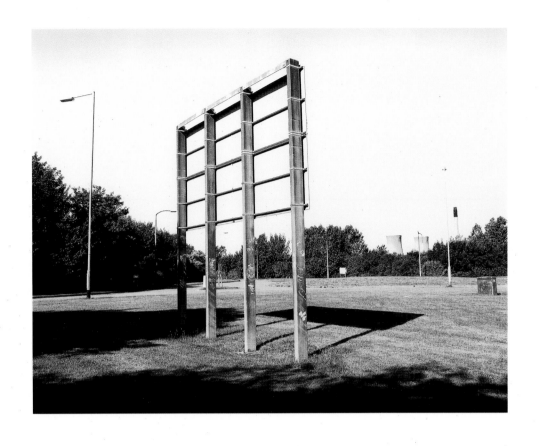

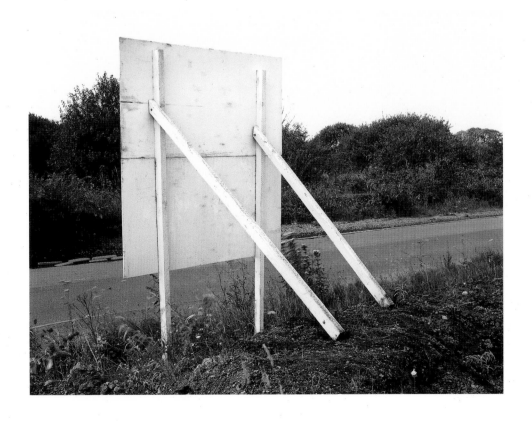

adam o'meara

Pollution Rose Human technological evolution has been concurrent with a rise in pollution levels, beginning with prehistory, when open fires affected the health of cave dwellers, resonating through William Blake's 'dark satanic mills' of industrial Britain and culminating with contemporary concerns about climate change. As civilisation has continued to make a mark on the landscape, so pollution has ultimately become the detritus of technological advancement. Port Talbot steel works and William Henry Fox Talbot's connection with nearby Margam Castle, home of the Talbot family, has been the inspiration behind *Pollution Rose*. The images were made by exposing sheets of photographic paper to the light pollution of the steel works at night, producing photographic silhouettes, referred to by Talbot as *sciagraphs* — shadow paintings (a term devised at a later date by Sir John Herschel).

tatjana hallbaum

Westend Having arrived in South Wales, a place where I have never been before, and driving along the motorway, with a sheet of paper in my hand indicating the junctions where I have to get off, one thing leads to another; I eventually find Westend. More or less by chance, I have discovered an amazing place, a world within a world, consisting of two rows of houses: Upper Westend and Lower Westend. To the south and east, behind a massive metal fence, looms Port Talbot steelworks. To the north the railway lines separate the community from the Margam hills, and to the east a small river runs behind yet another border, a concrete wall. The only way to get to Westend is via a single lane underneath the railway bridge. The experience seems to me almost like finding a track to a secret garden...

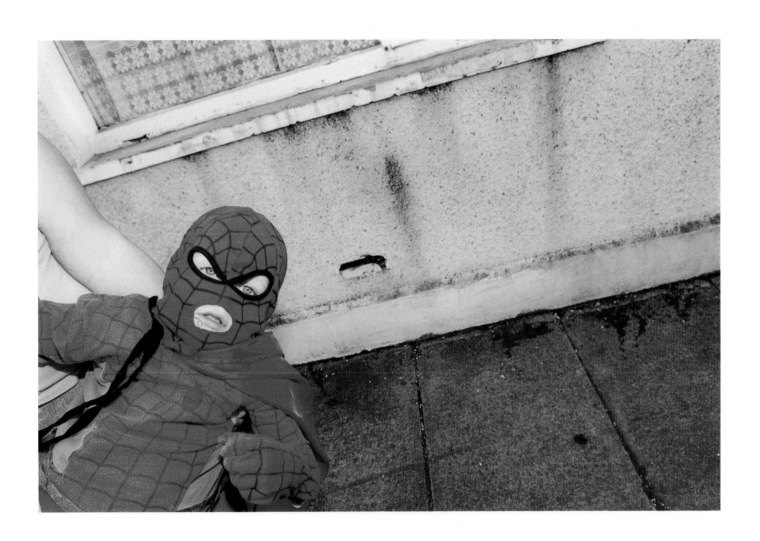

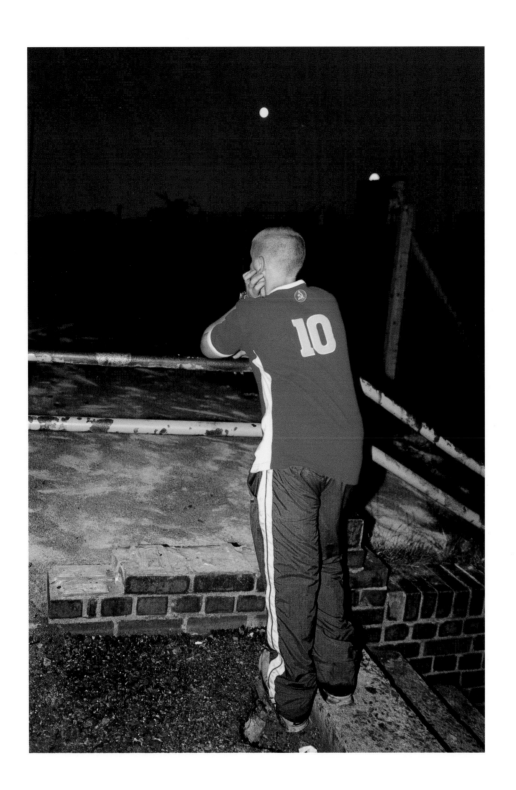

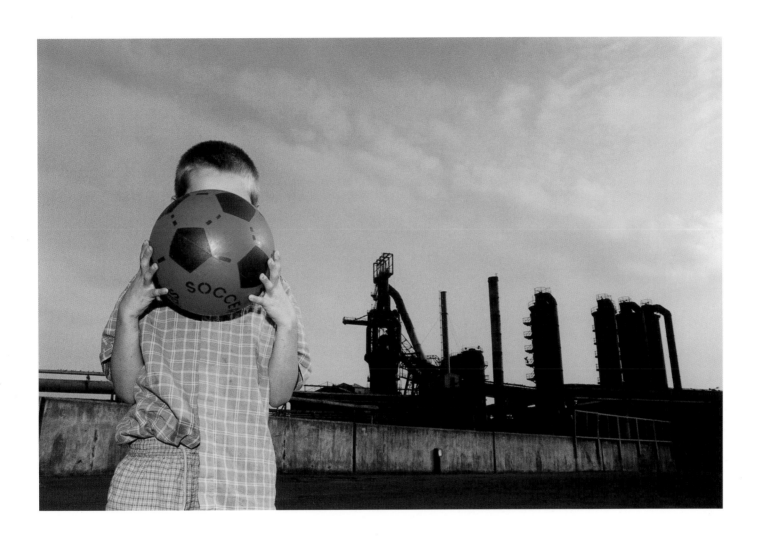

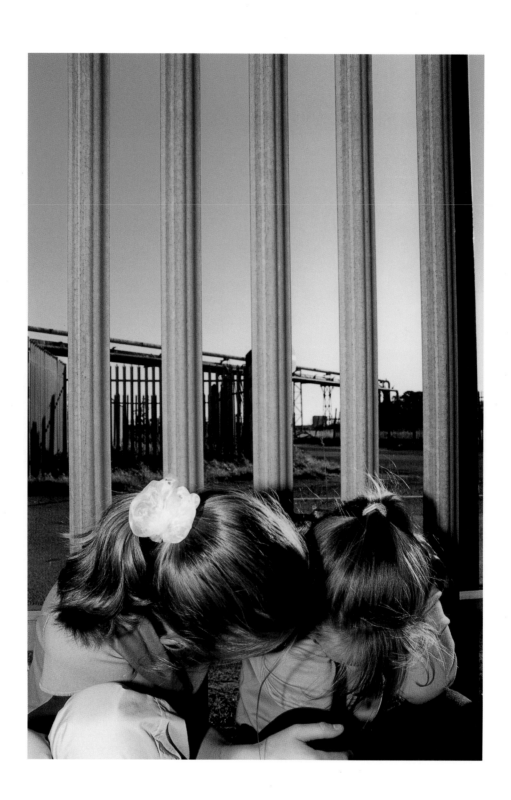

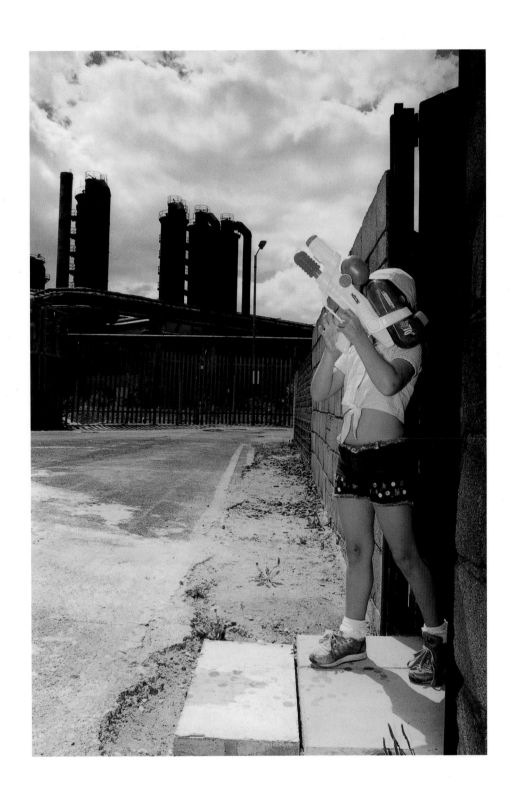

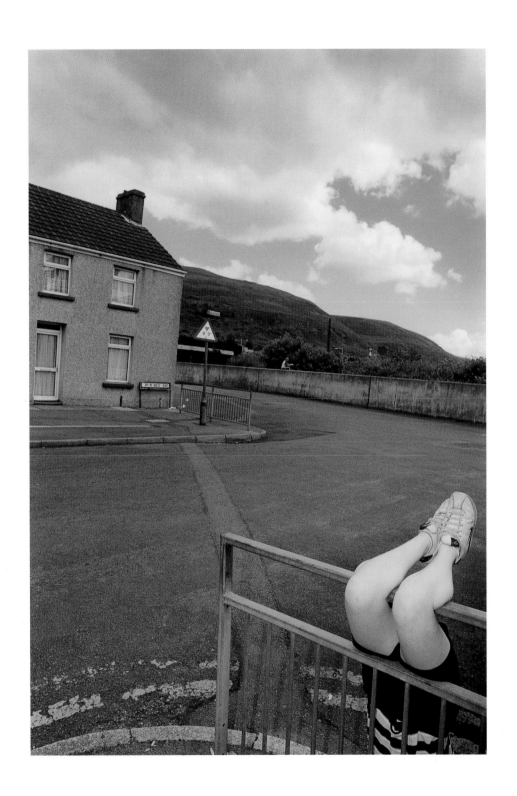

richard page

Spoiled In response to the notion of heritage this work focuses on the opposite, spaces that are not valued as culturally important and are not seen as worth protecting. Wastelands fall outside this coherent picture of the British landscape and history, and are therefore, by consequence, deemed extraneous: ex-industrial sites or undeveloped patches of land which proliferate throughout the diverse landscape of Port Talbot, bordering the pockets of 'valuable' land; golf-courses, housing estates, leisure centres, retail parks and industrial complexes. Historically, images of the landscape have been informed by the economic, cultural or visual worth of the land; the wasteland has traditionally been left out of the pictorial agenda. My landscape images explore the edges of the wastelands where they meet, almost unexpectedly, with other environments such as the retail or residential, but always observed from the context of the wasteland.

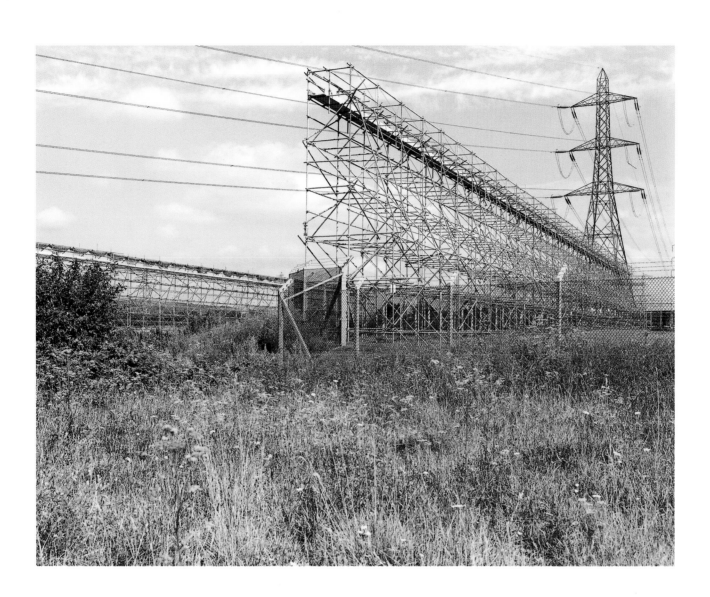

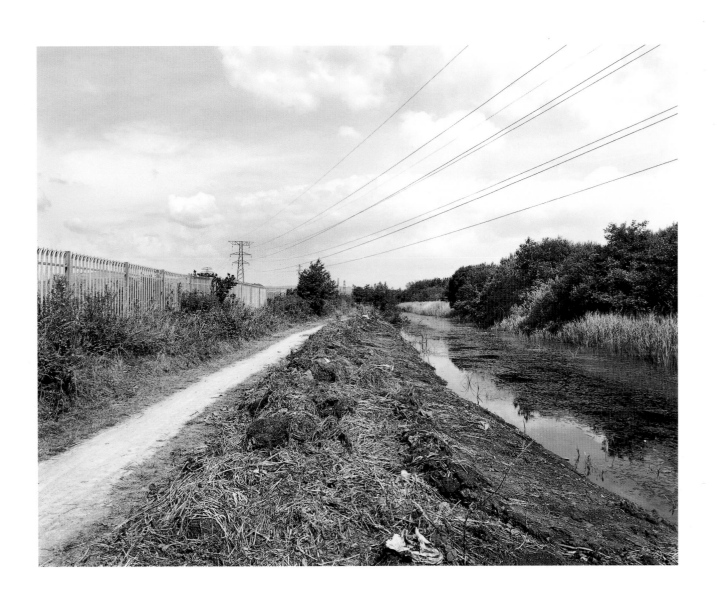

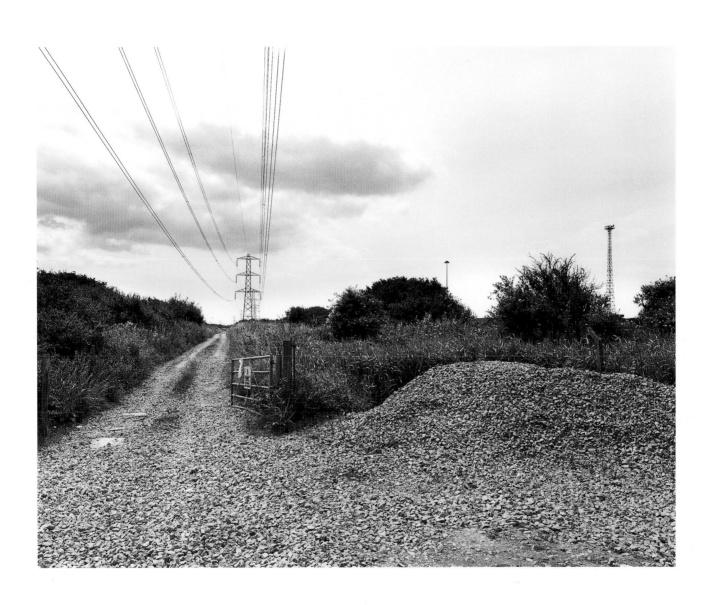

chris dyer

Integration Having a friend who lives in a remote area where fellow residents protested against the erection of wind generators — on the premise that they would be a blight on the landscape — has been instructive for me. It has informed my approach whilst photographing in the Margam/ Port Talbot area, and I realise that adaptability is a wonderful human quality that has so obviously been exercised by the local communities here. The area is a definite example of how contemporary life can successfully function in a landscape that is so seriously shadowed by heavy industry. In an 'ideal' world, it appears that industry and nature are at opposition with each other. The people are the peacekeepers living between the two, who attempt to achieve a harmonious situation by using each one as much as the other.

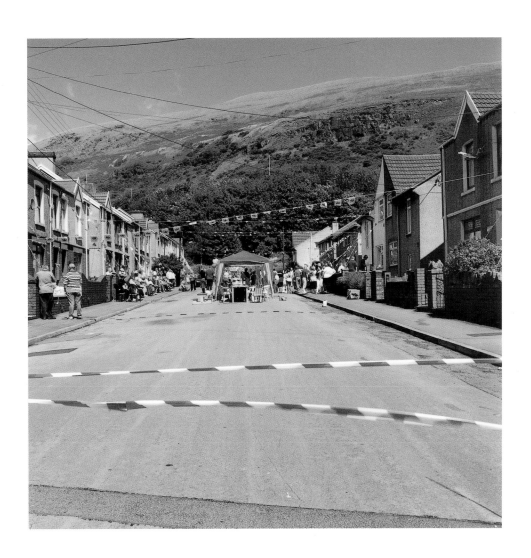

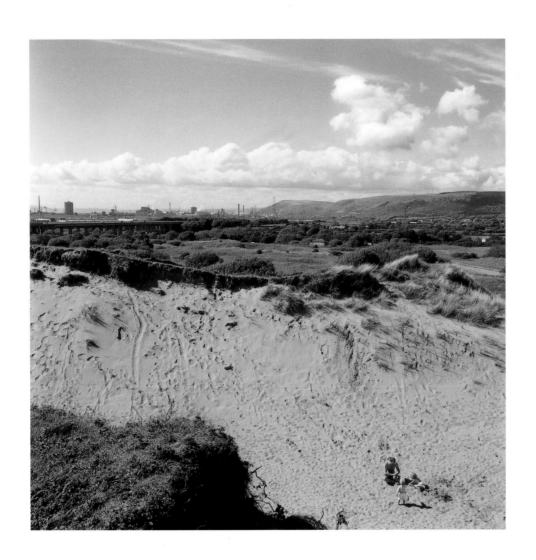

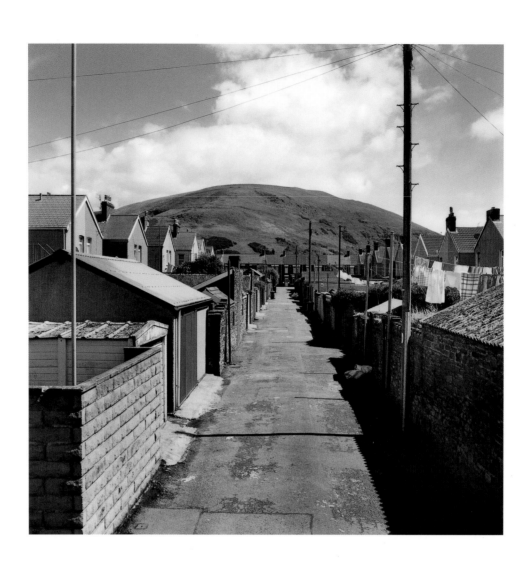

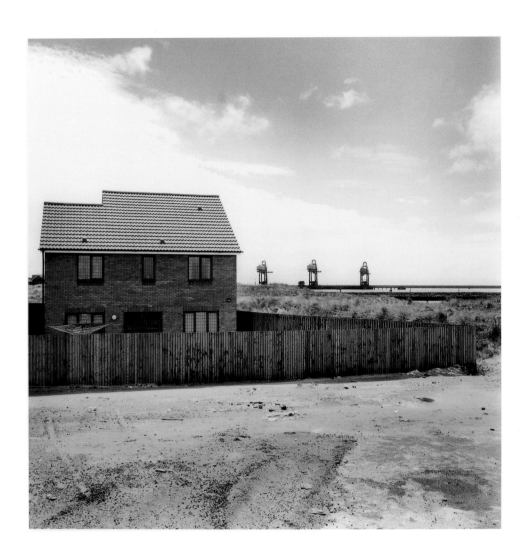

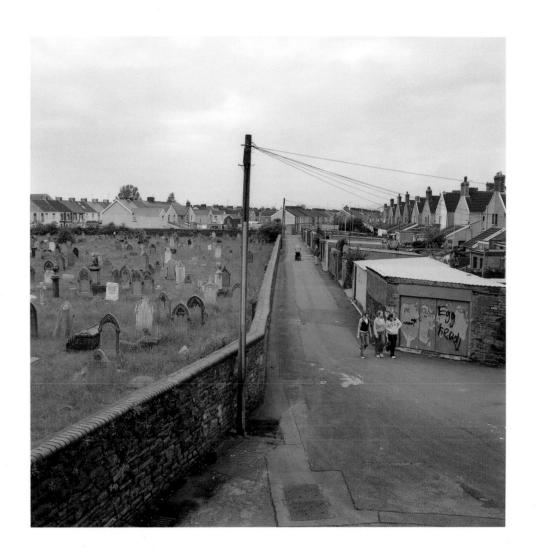

matthew pontin

Resurrected Landscapes The domestication of the unfamiliar by capturing it on film is evident strongly within visual representations of the landscape. Photography has altered the notion of presence and has become securely attached to experience. The human capacity to move from place to place both physically and imaginatively is driven by a desire for the 'somewhere else'. This body of work explores a non-travel experience where virtual tourism occurs through digitally exploring 'resurrected landscapes' of the Margam area. The simulation is heightened and revealed directly through a large-format viewfinder; informing a presence within the landscape, defined by the nature of this cumbersome and architypal photographic apparatus. The medium's historical restraints are liberated in the rapidity of the virtual experience. *Resurrected Landscapes* question not only the exactitude of photography but also emphasise 'seeing' and its importance when considering the landscape.

karen ingham

Figures In A Landscape At leisure: a figure looks out from an ornate gabled window. The person

surveying the landscape from Margam Castle is but a passing tourist, assuming for a moment the

privileged vantage point of the once powerful landlord. Meanwhile, in the parkland below, a young

girl peers through a pair of binoculars, focusing on the elevated country estate, now sadly devoid of

luxurious trappings. Allegorically, these two figures represent the boundaries of eighteenth and

nineteenth century landscape photography, the aesthetic and the scientific, manifested as the desire

to invent optical devices designed to improve and eventually capture the idyllic landscape. The resulting

images exaggerate and blur the boundaries between painting, photography and the nostalgic postcard.

The figures in the Margam Park landscape are a reminder that the landscape has become a carefully

stage-managed backdrop, an allegorical wonderland where the traditionally surveyed have become

the new surveyors.

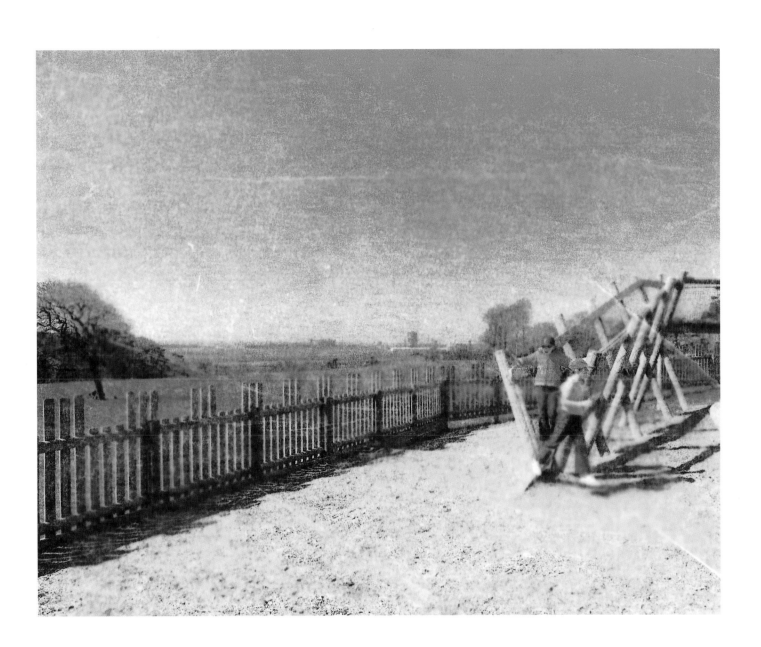

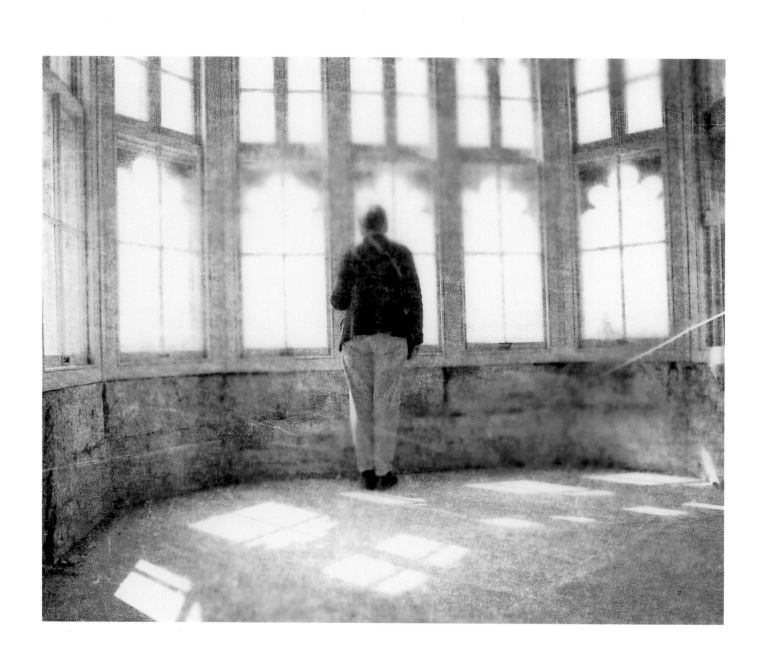

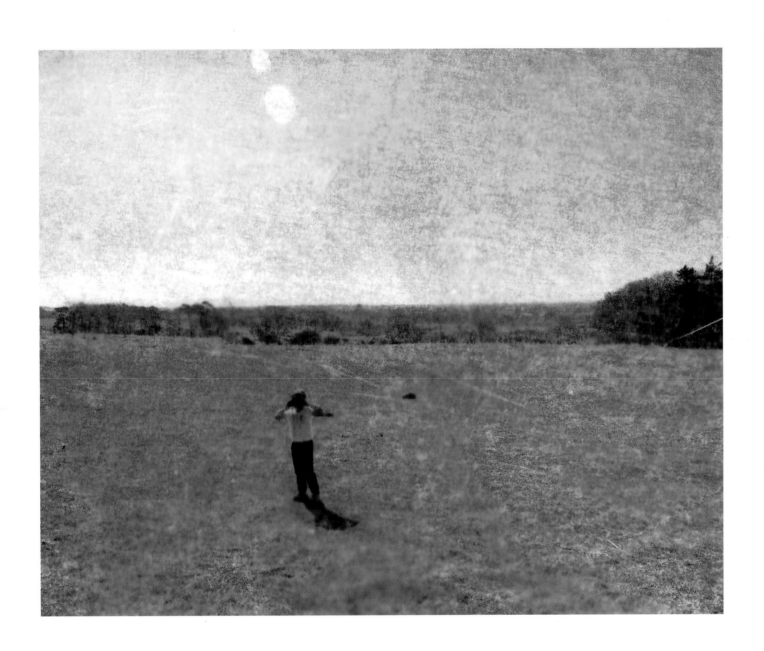

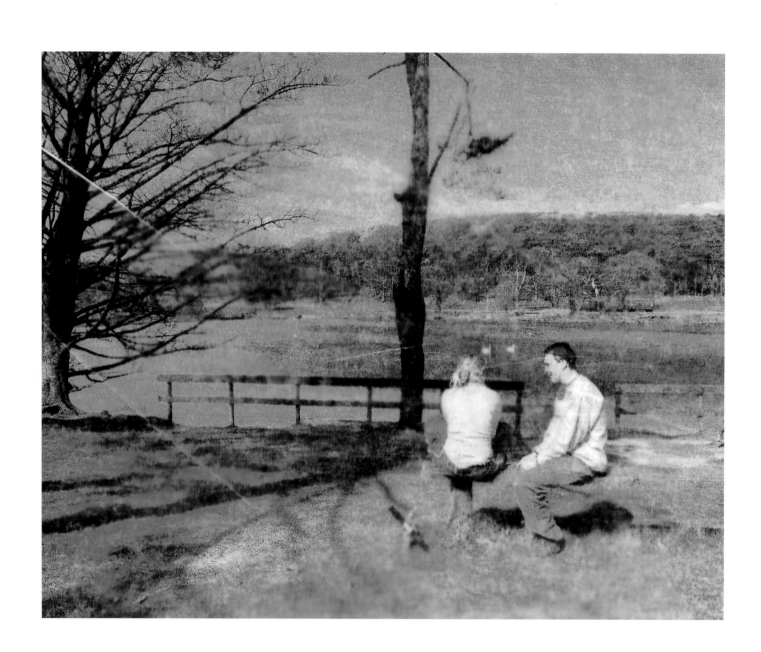

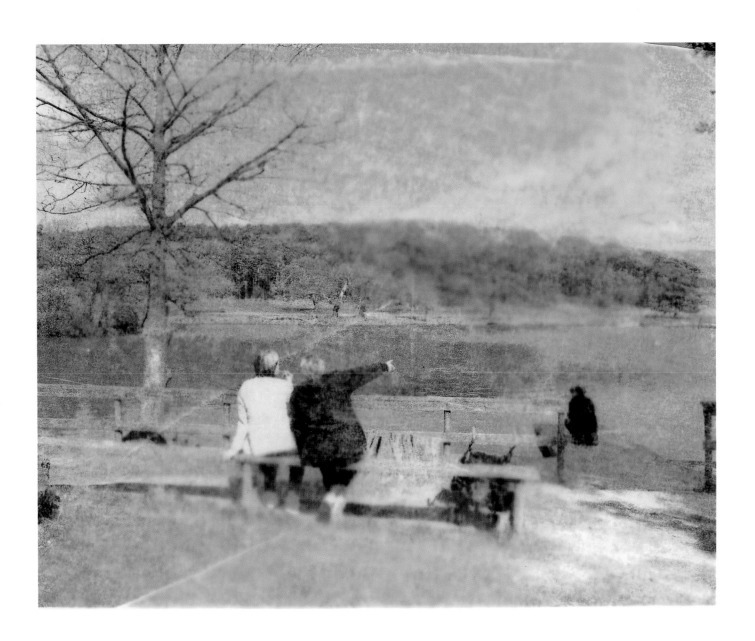

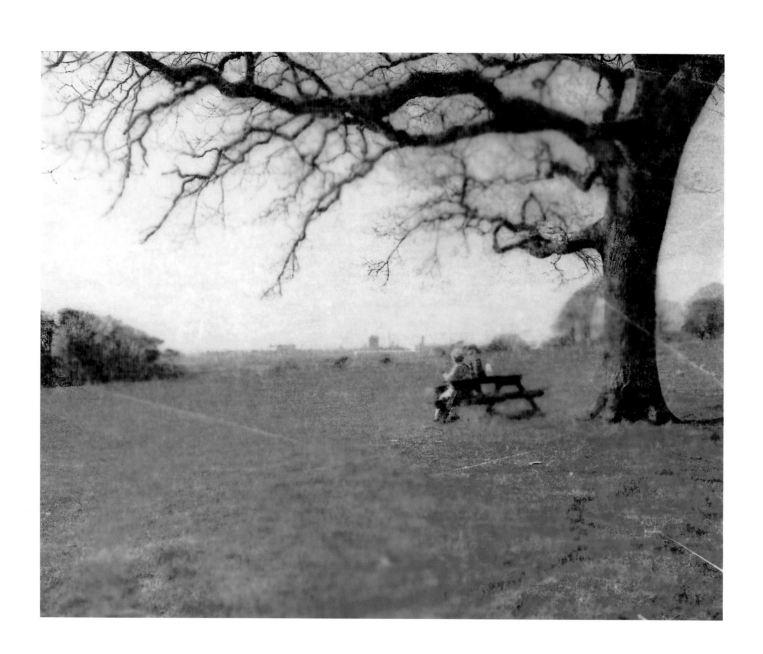

the artists

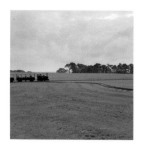

Chris Dyer graduated in Photographic Arts at Swansea Institute of Higher Education in 1999. Since then he has worked as a freelance photographer and assistant. His clients include The Bank Media, *The Sunday Times* and *The Independent on Sunday*. He has also taken part in a number of group shows and has held solo exhibitions, including *The Domestic Animal* at the Watershed Media Centre, Bristol and *Eccentric Britain* at Islington Arts Factory, London. He moved to Cornwall in 2002, where he and his wife will be opening a photographic gallery specialising in geographically topical projects and commissions.

Peter Finnemore was born in Llanelli, and his work is firmly rooted in questions of national and cultural identity and 'place'. He received his degree in Fine Art Photography at the Glasgow School of Art and later completed an MFA in Photography at the University of Michigan, Ann Arbor, USA. Since 1985 he has exhibited widely, nationally and internationally. His first major solo show, *Gwendraeth House* was toured by Ffotogallery and was accompanied by a book of the same name. He currently lives and works in Carmarthenshire and lectures in the Photography Department at Swansea Institute of Higher Education.

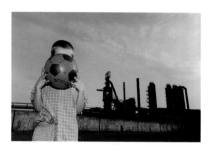

Tatjana Hallbaum was born in Hanover, Germany. After a brief spell studying languages in London in the early 90s, she began an apprenticeship in Photography at the Lette-Verein in Berlin. From 1996-1998 she studied Fine Art Photography at the Glasgow School of Art, before returning to Germany to complete her photographic studies. She is currently in her final year on the Degree Course in Photojournalism at the Fachhochschule für Medien und Design in Hanover. She has exhibited in group shows in Glasgow, Japan, and Germany.

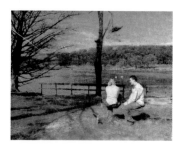

Karen Ingham was born in England and raised in a peripatetic Texan oil family living in the US, Germany and Norway before returning to Britain to study photography and time-based arts at Nottingham Trent University. Ingham has been based in Wales since the early 90's exhibiting and curating internationally. Recent publications (with accompanying gallery shows) include *Paradise Park*, Seren, 2000 and *Death's Witness*, Ffotogallery, 2001. Ingham was awarded a research M.Phil. by the University of Wales in 2001 and is currently head of the Centre for Lens-Based Arts at Swansea Institute of Higher Education.

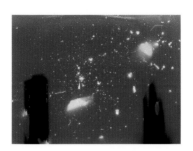

Adam O'Meara is a practising photographic artist currently working in the media production department of the University of Lincoln. O'Meara has worked on numerous commissions and residencies involving site-specific artworks and the notion of 'place'. He is currently studying for an MA in Photography at De Montfort University, Leicester.

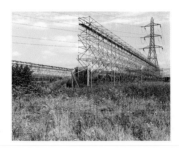

Richard Page is an English photographic artist currently based in Cardiff. His work has been included in a number of exhibitions in Wales and England, including *A470* at Oriel Mostyn Gallery in Llandudno and Chapter, Cardiff. His first major solo touring show, *Landscapes from the Tryweryn Valley* was exhibited at the RPS in Bath; his recent work was also shown as part of *'But still...'* at G39, Cardiff in 2002. A graduate in Documentary Photography at University of Wales College Newport, Page is currently studying for an MA in Photographic Studies at the University of Westminster, London and lectures part-time.

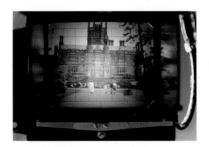

Matthew Pontin was born in Oxford but raised and educated on the Isle of Wight. He initially trained as an architect in Liverpool before studying contemporary photo-journalism at Swansea Institute of Higher Education in 2002. He was awarded the Alex Proud Photography Prize from an exhibition at The Well, London. He has worked on diverse commissions from assignments for Guinness World Records to advertising for the NHS. In 2002 he received the Geoffrey Crawshay Memorial Travelling Scholarship to continue a personal project exploring the nature of virtual and actual travel experiences.

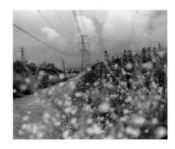

Miranda Walker is a graduate in Documentary Photography at University of Wales College Newport. Solo exhibitions have included *Skeleton in the Cupboard*, Hereford Photo Festival, 1996 and *Madonna*, Kemble Gallery, Hereford Photo Festival, 2000. Group exhibitions include *Diverse Signals*, Ffotogallery, Cardiff, 1995 and touring, and Cardiff Bay Art Trust *Selection*, 2000. Her work is included in the publications *Viewfindings*, West Country Books, 1994 and *Wales in our Own Image*, In Books, 1999. She was the recipient of an Arts Council of Wales Travel Grant in 1995 and her images are included in the collection of Bibliothèque Nationale, Paris.